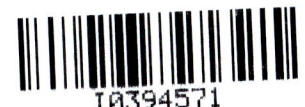

DEADLINE DRAWINGS

Volume 1

KYLE T. WEBSTER

All Images ©2007 Kyle T. Webster
www.kyletwebster.com

Deadline Drawings: Volume 1 copyright © 2007 Kyle T. Webster. All rights reserved. Printed in the United States of America. No part of this book may be used or reproduced in any manner whatsoever without written permission except in the case of reprints in the context of reviews. For information, email *kyle@kyletwebster.com*

ISBN: 978-0-6151-7063-3

This book of drawings is dedicated to my wife and family for their constant love and support. Thank you!

I would additionally like to thank the many editorial art directors I have worked with this past year: Pete Morelewicz, Darrick Rainey, Alice Lewis, Kelly Lewis, José Reyes, Seth Rogovoy, Aaron Huffman, Aaron Edge, Pam Shavalier, Michael Shavalier, Thomas Gogola, Stephanie Glaros, Nick Jehlen, Tak Toyoshima, Mike Simmons, Rob Williams, Vivian Selbo, Katie Swarz, Ricardo Soliz, R. Scott Wells, Tyler Darden, Nancy Stetler, Lisa Summerell, Chris Rank, Monica Fuentes, Viola Smolla, Jandos Rothstein, Jay Vollmar, and Kimberley Smith.

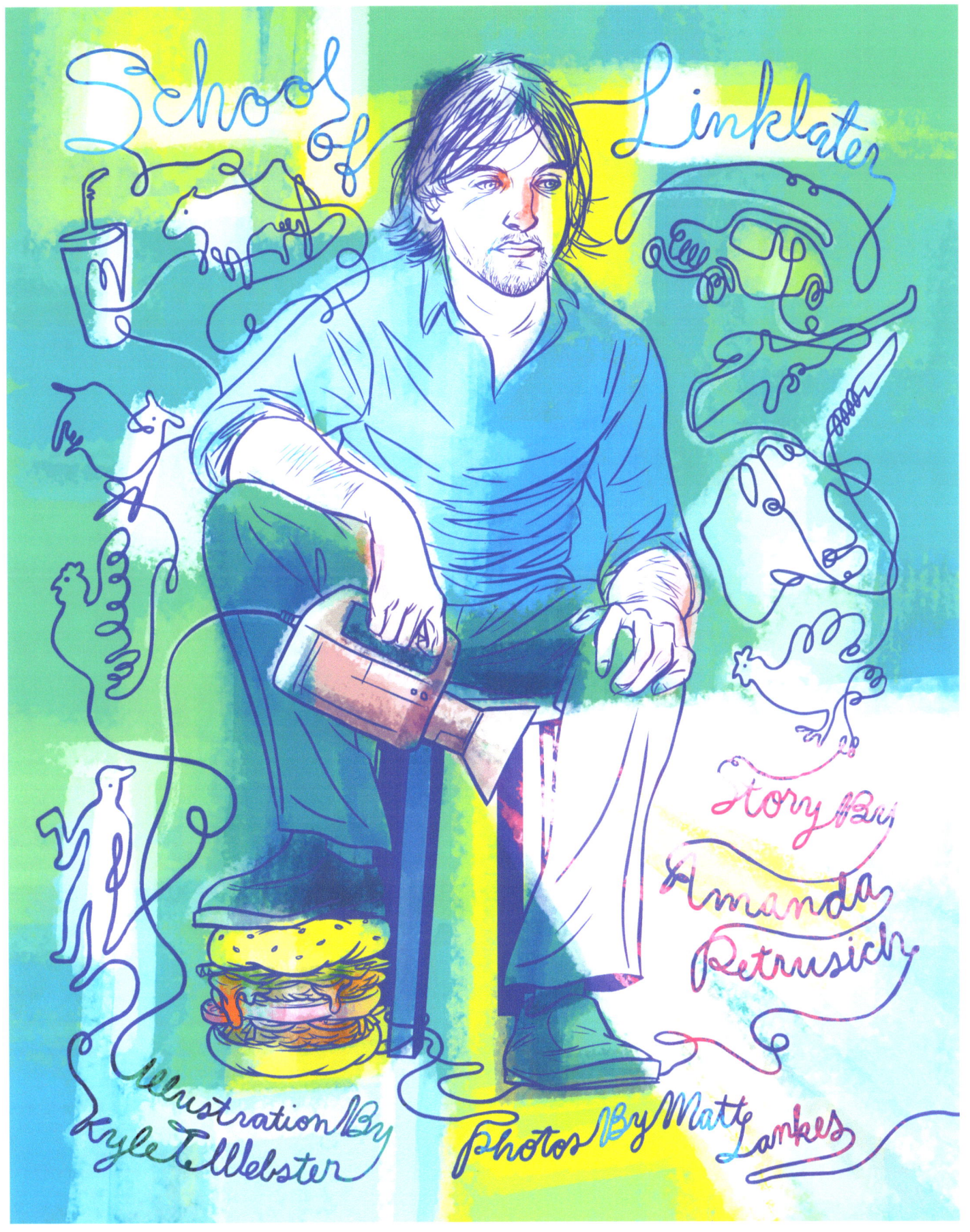

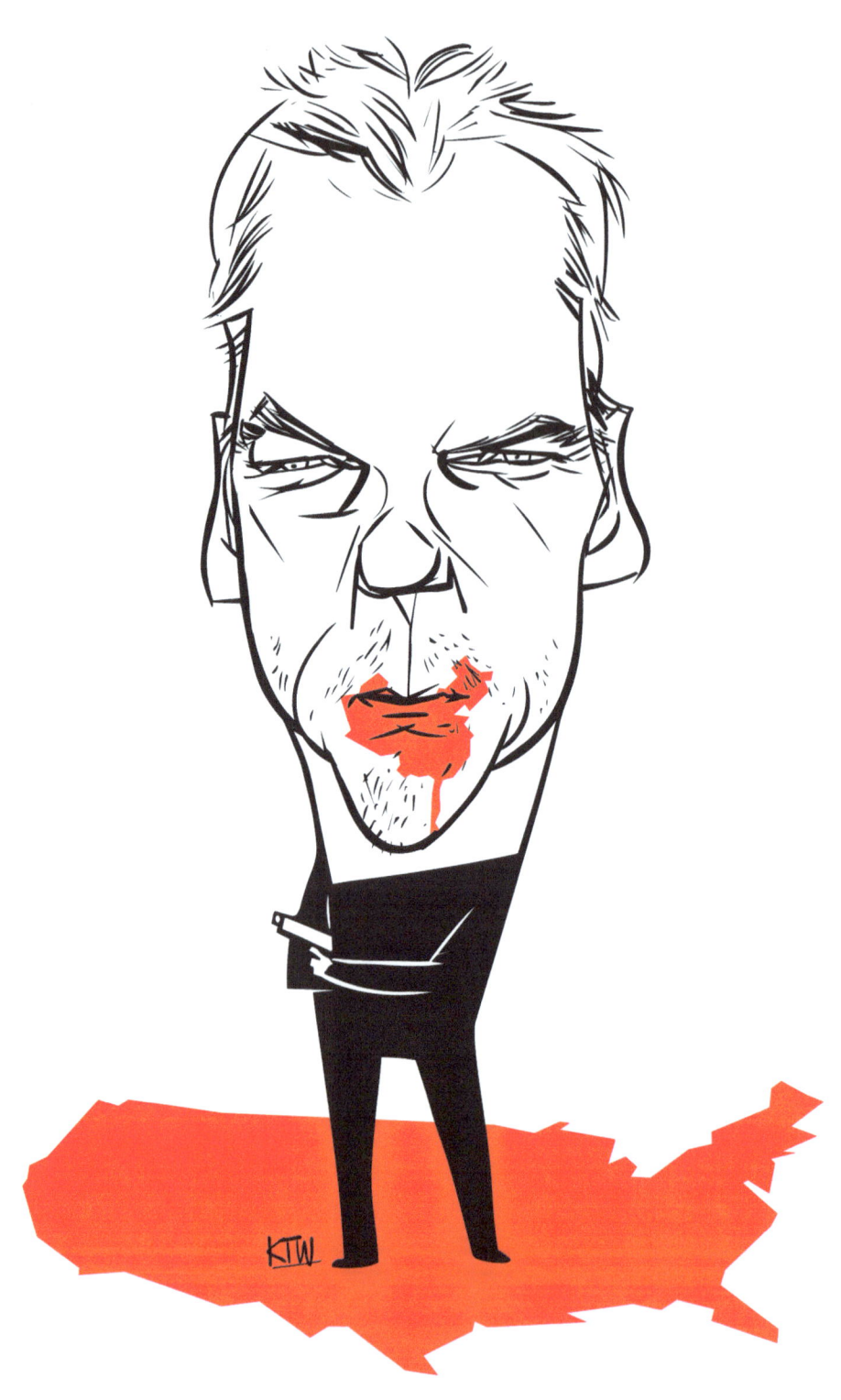

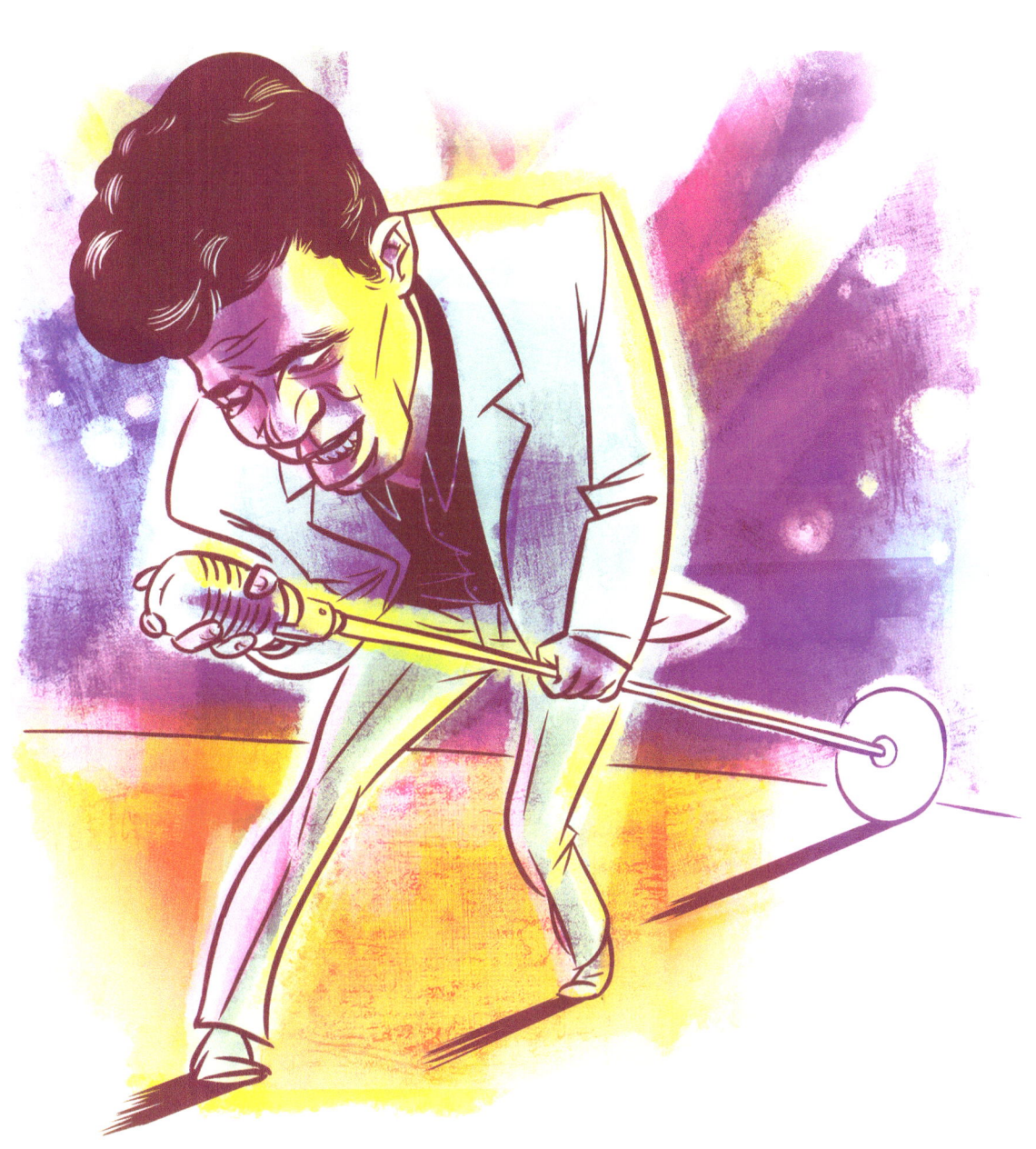

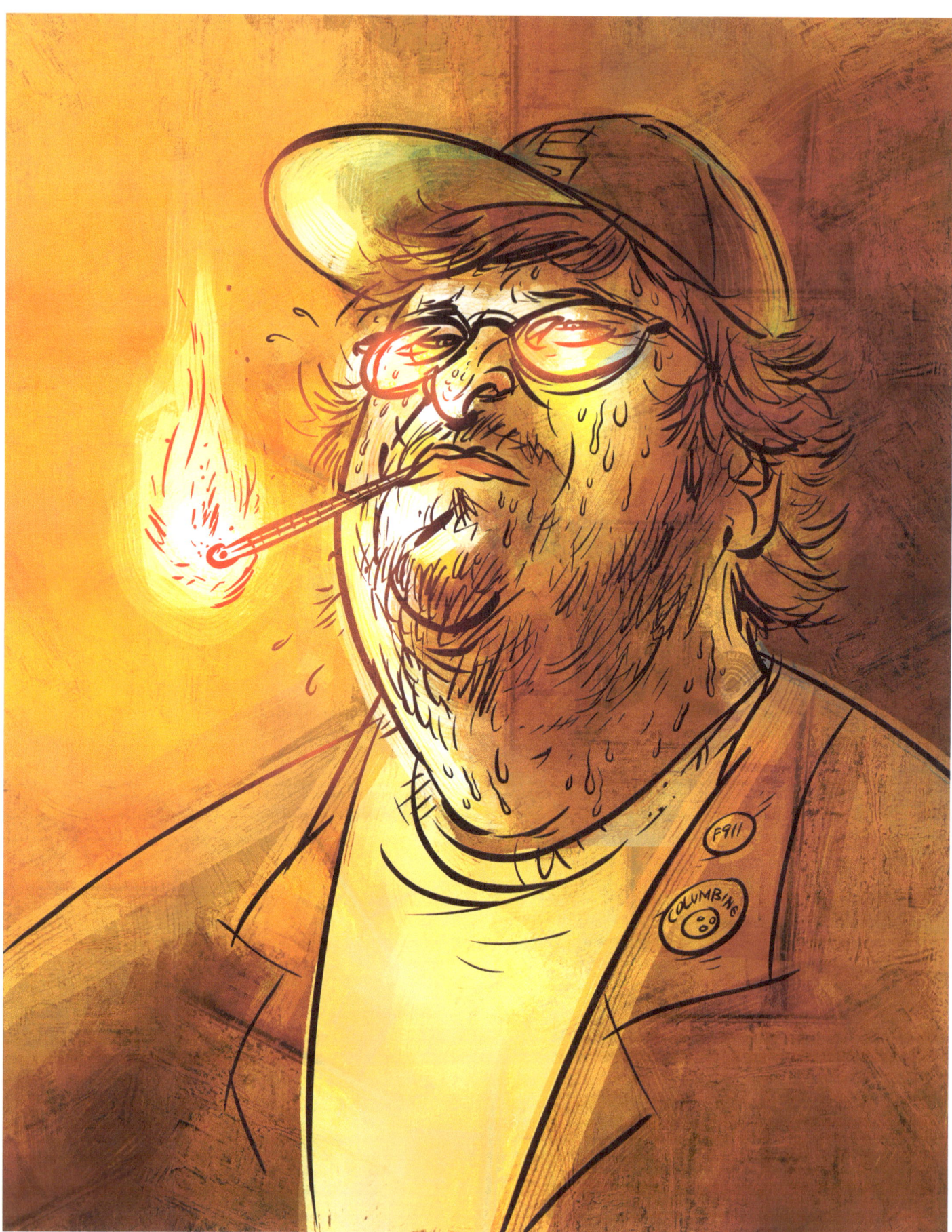

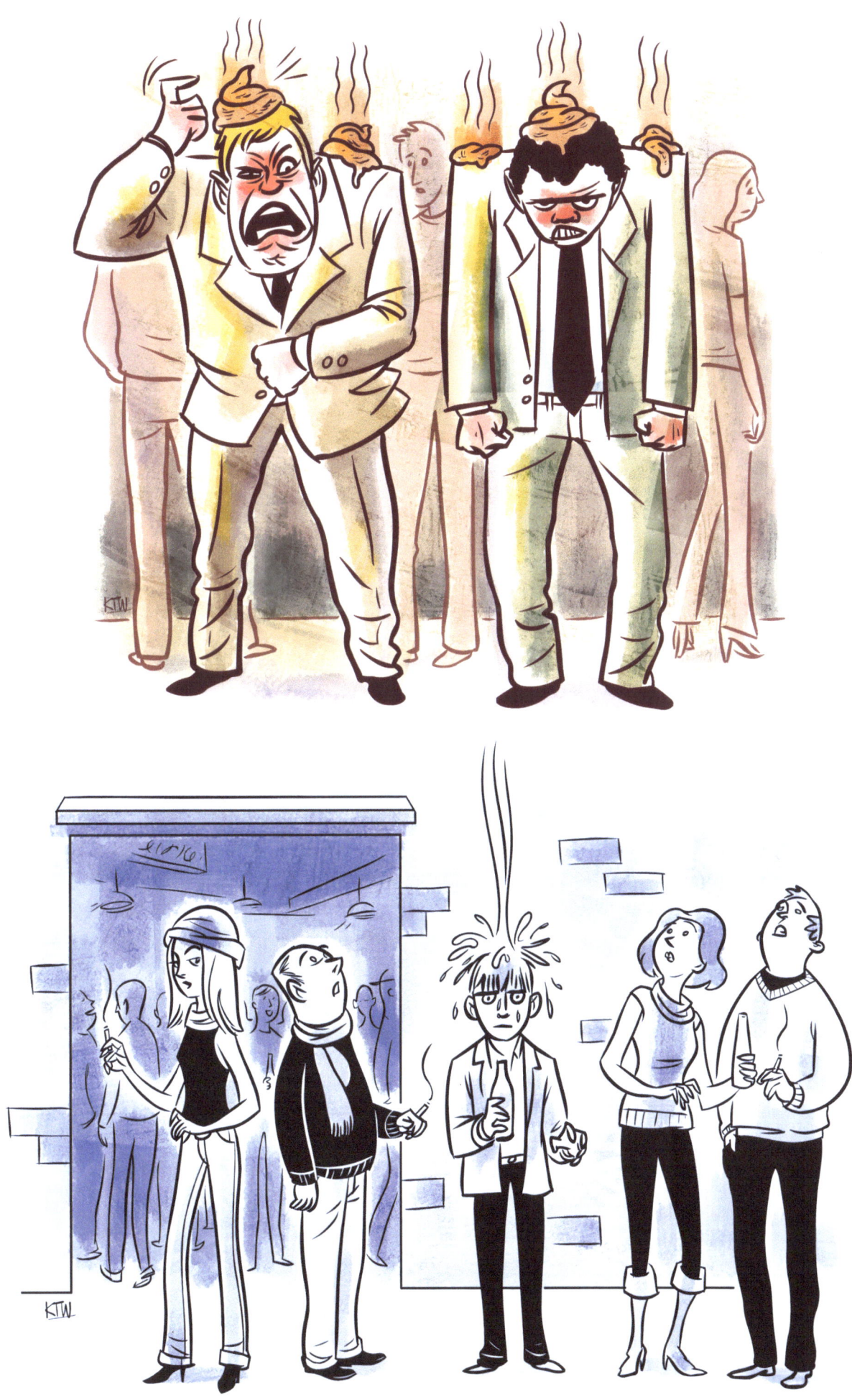

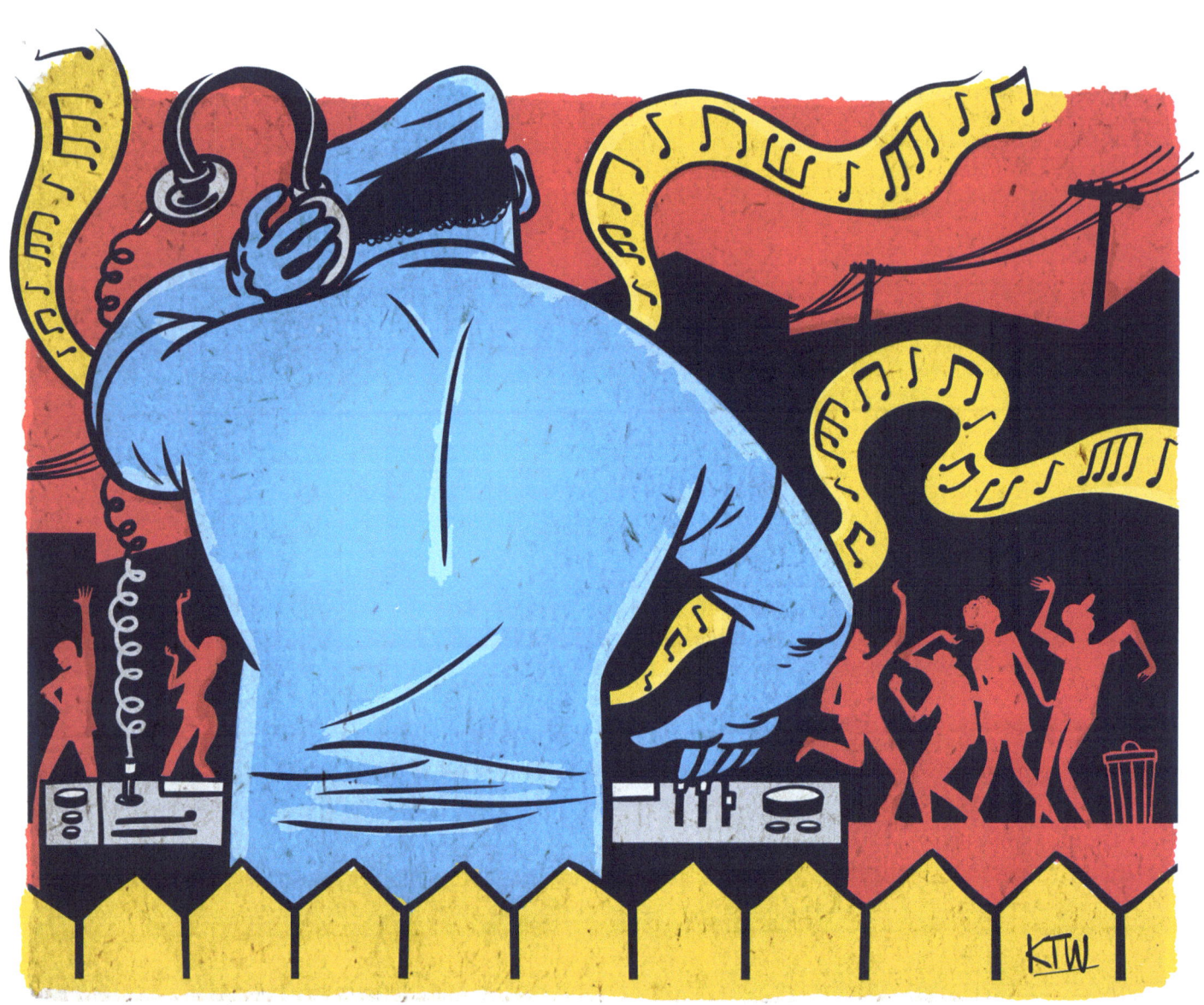

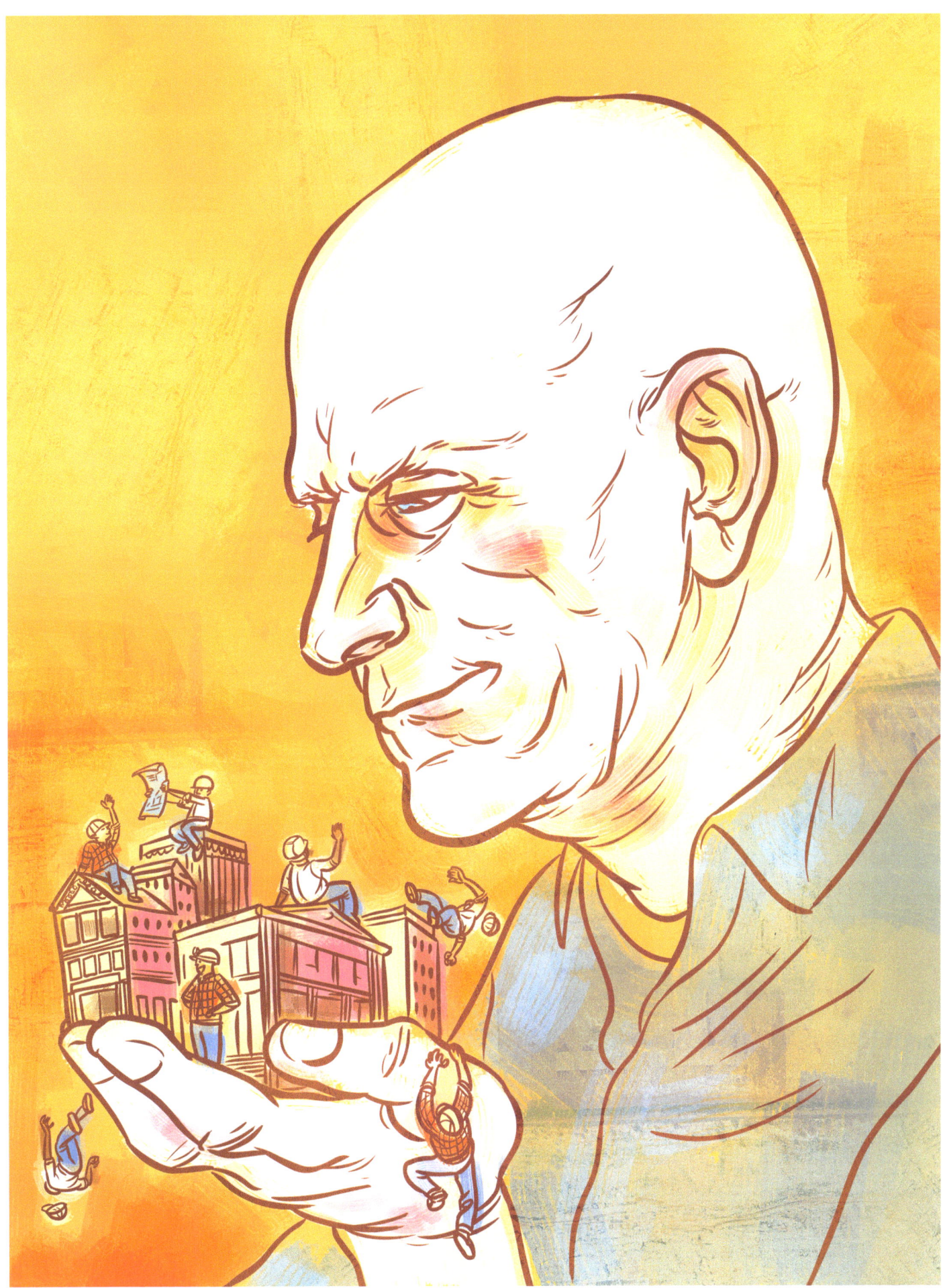

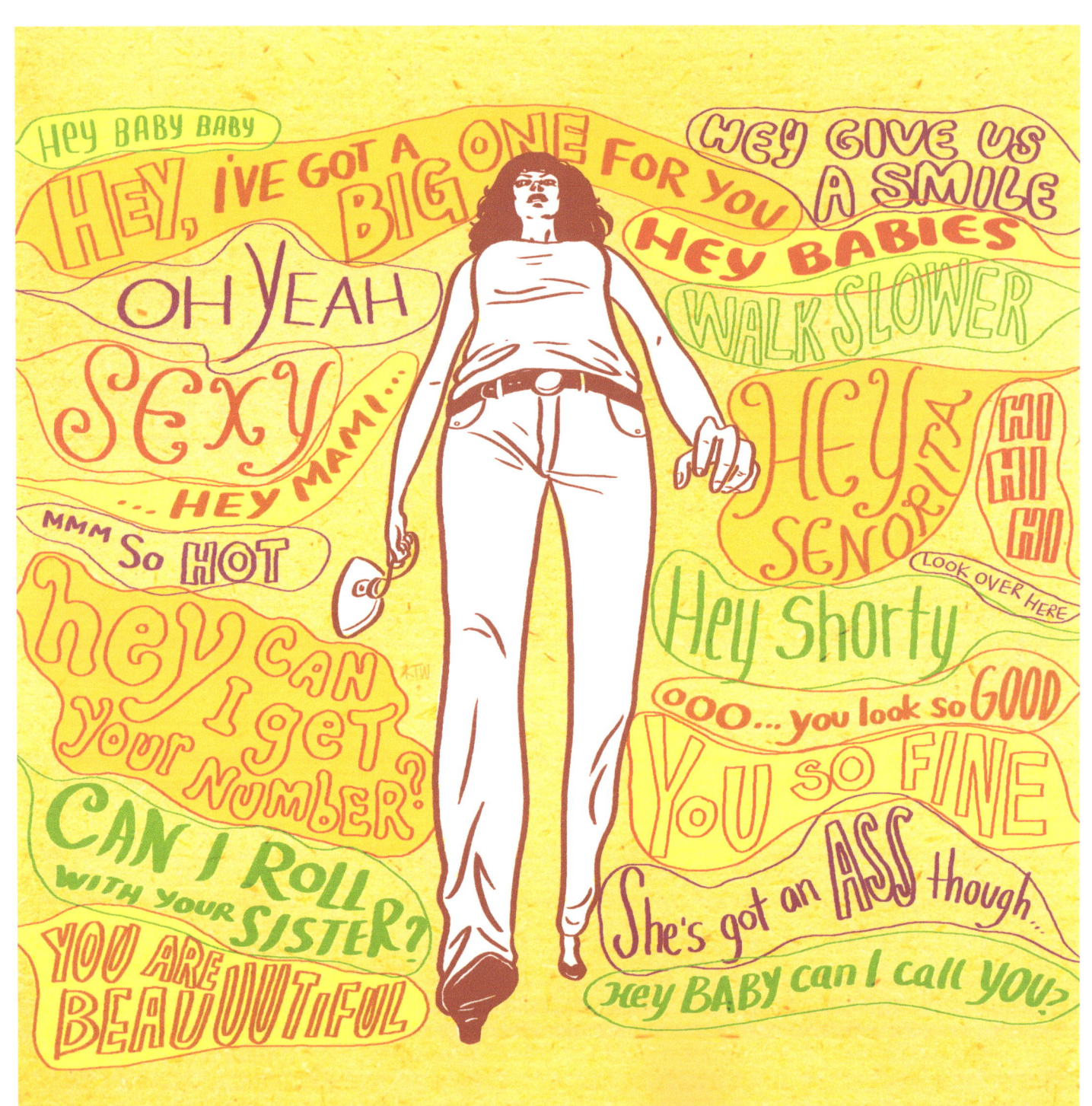

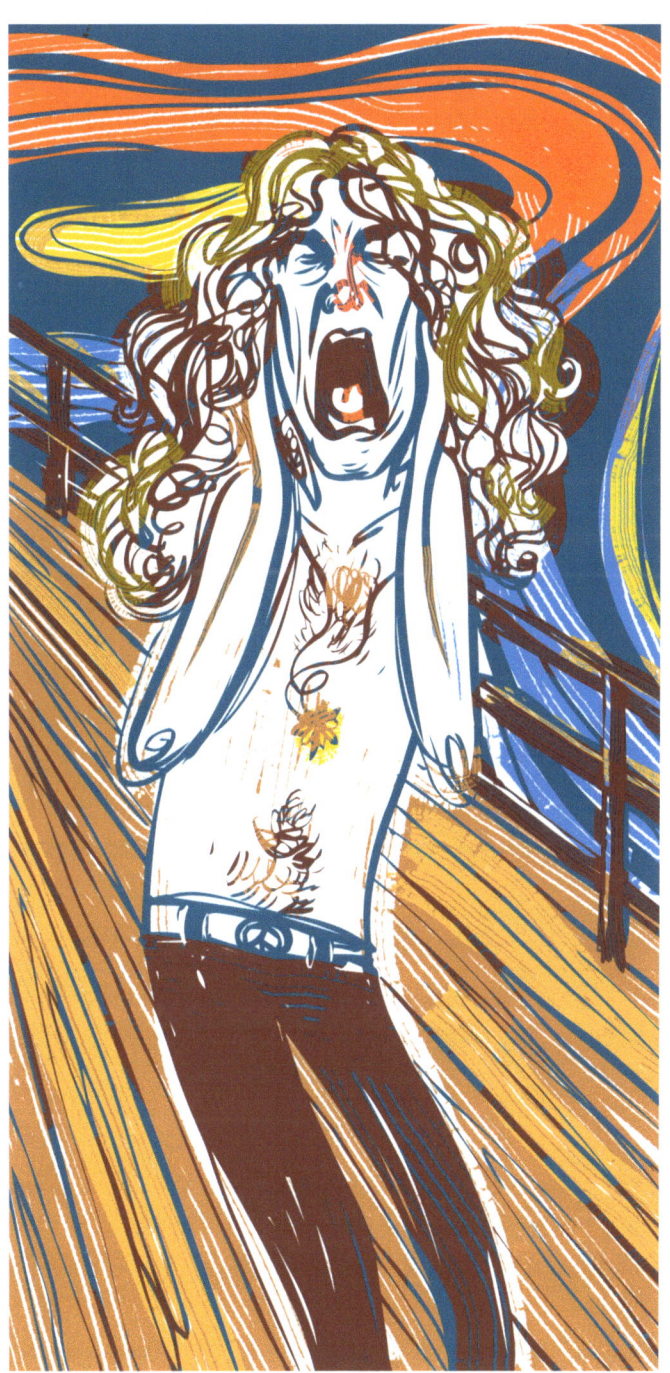

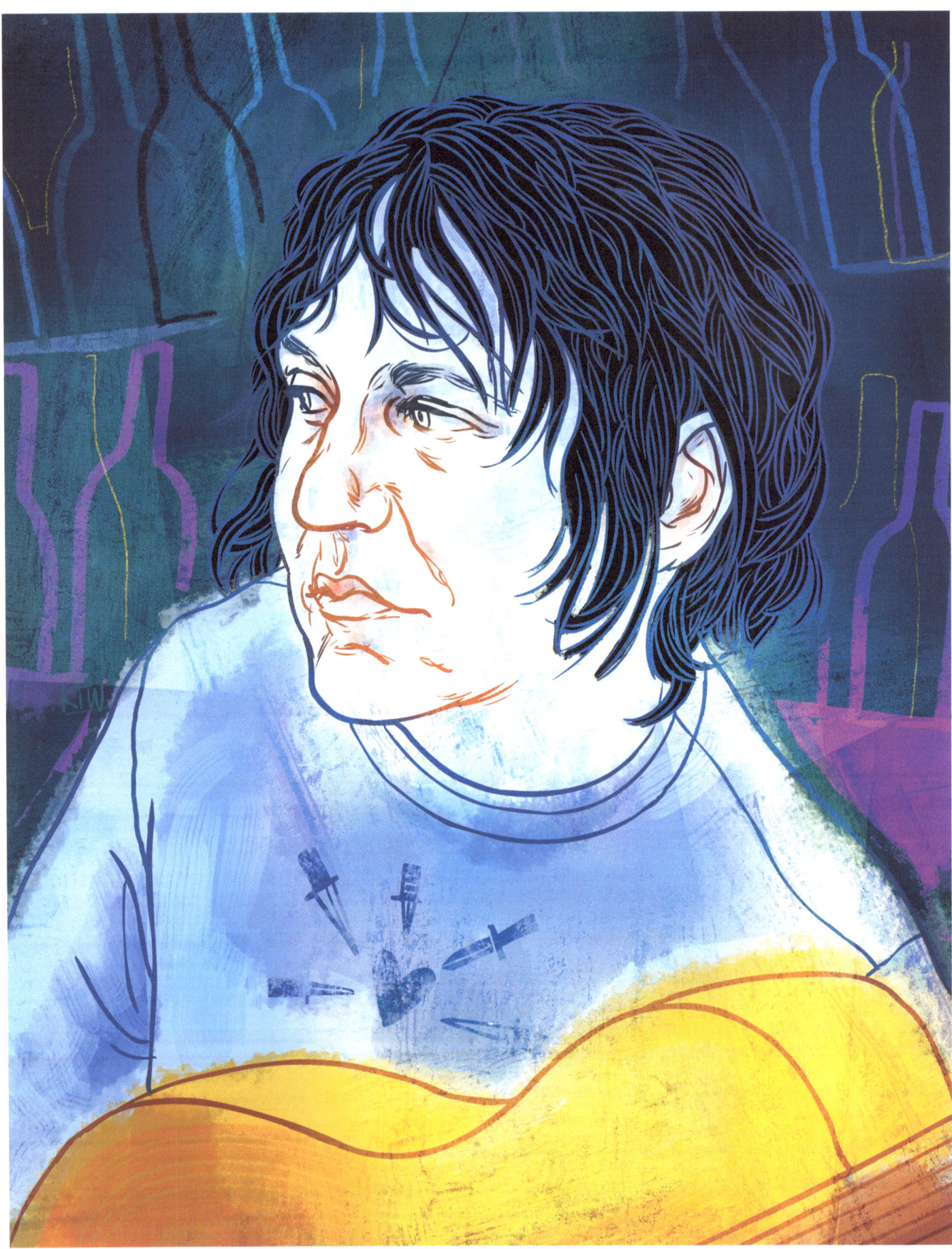

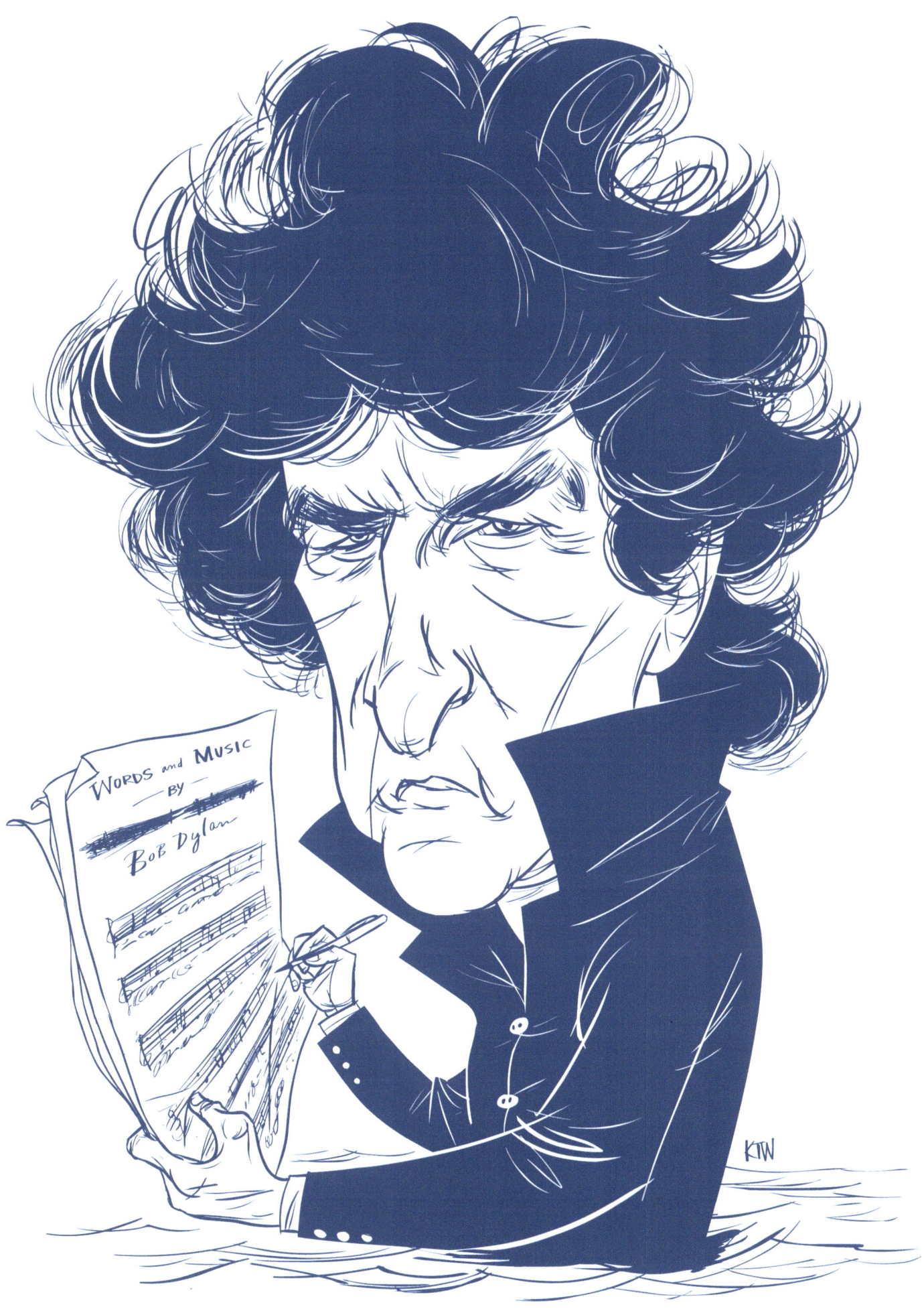

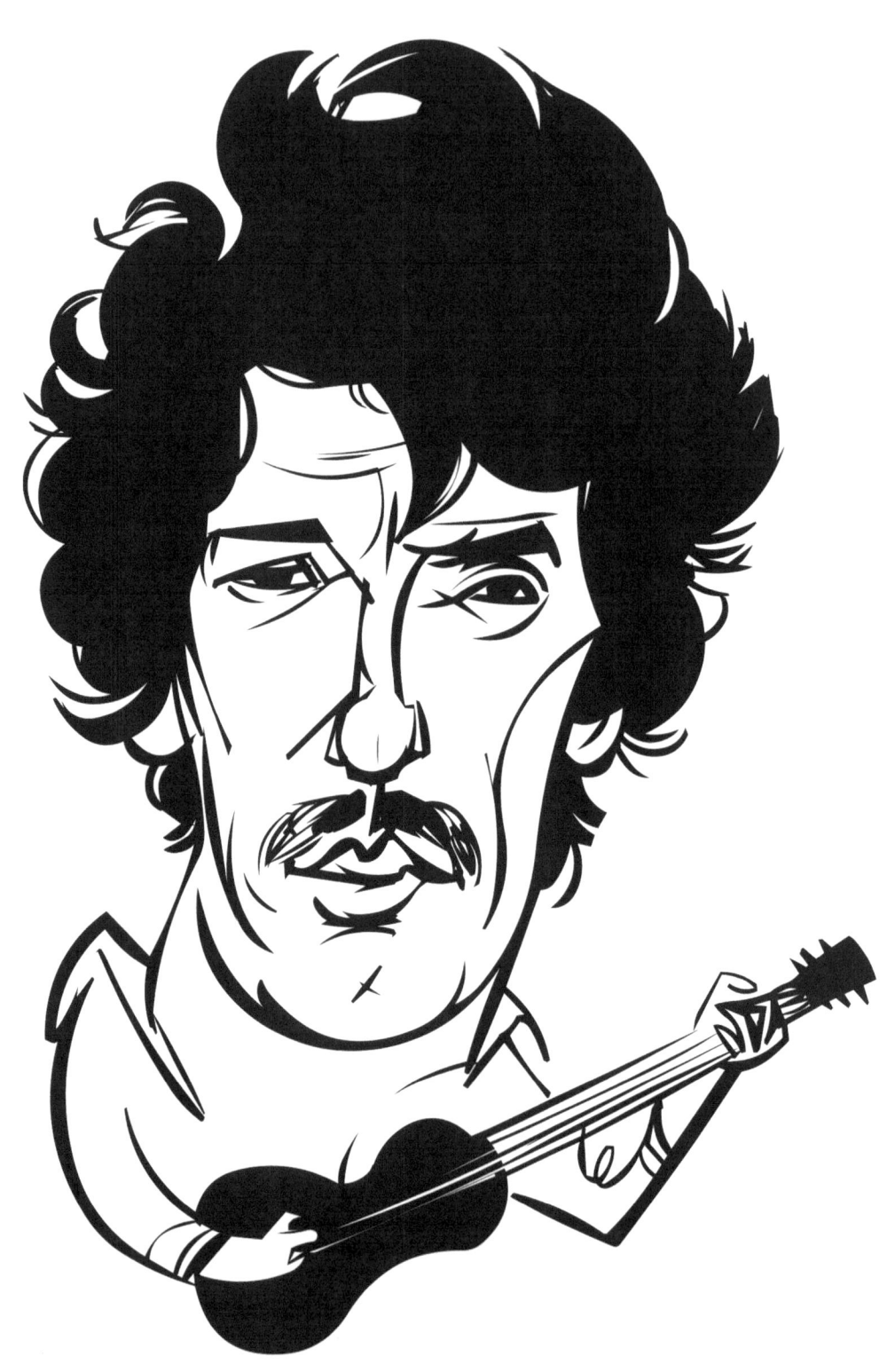

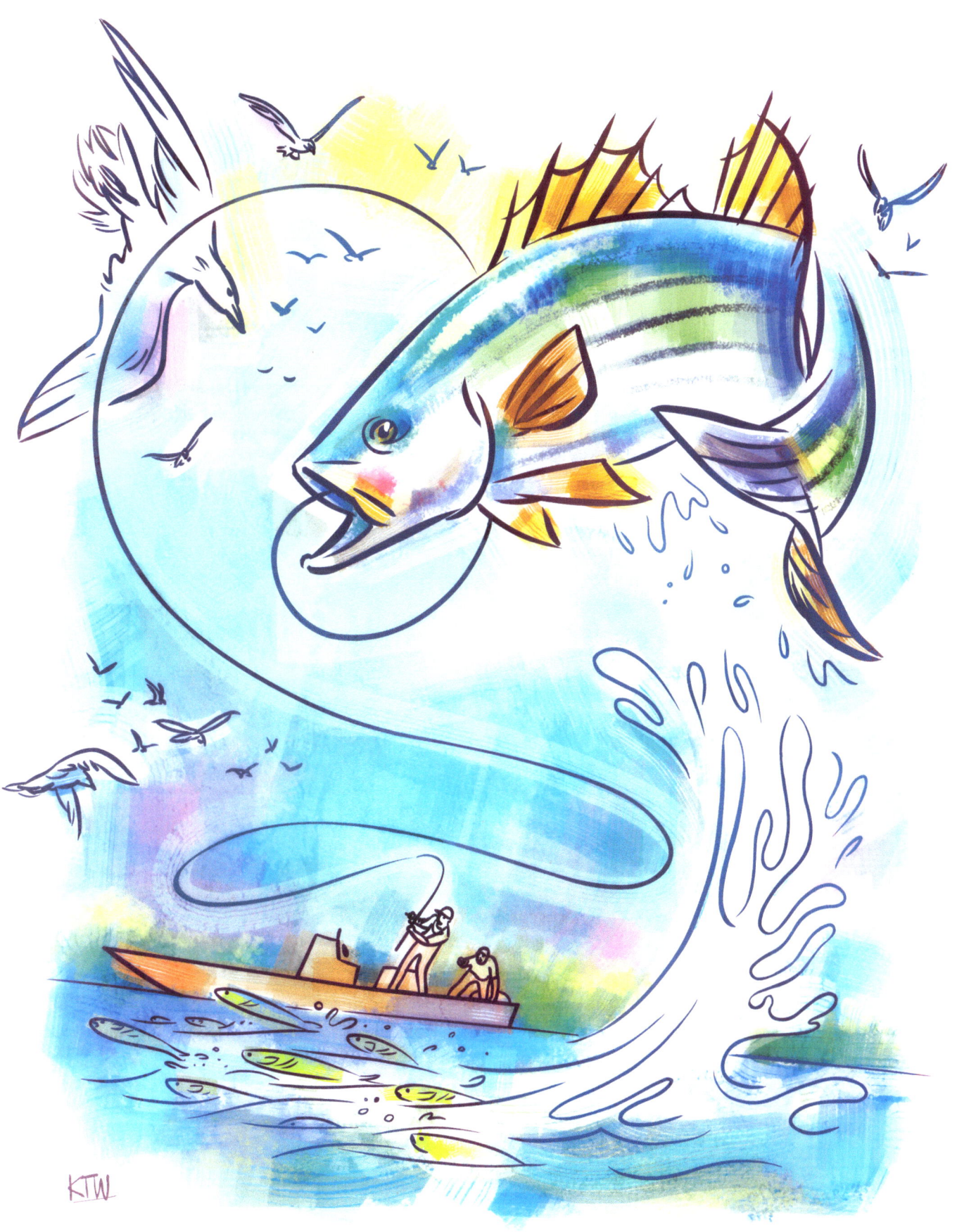

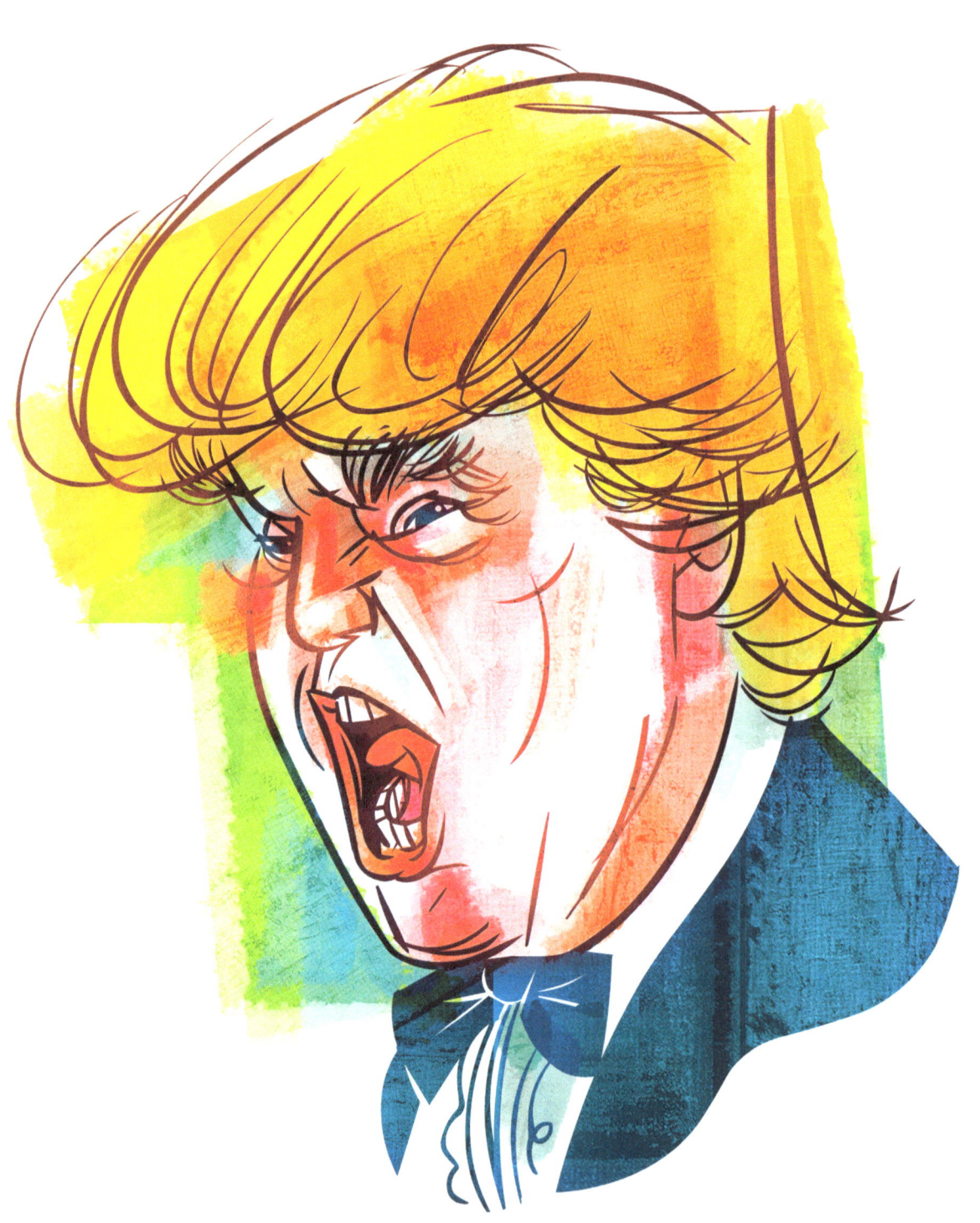

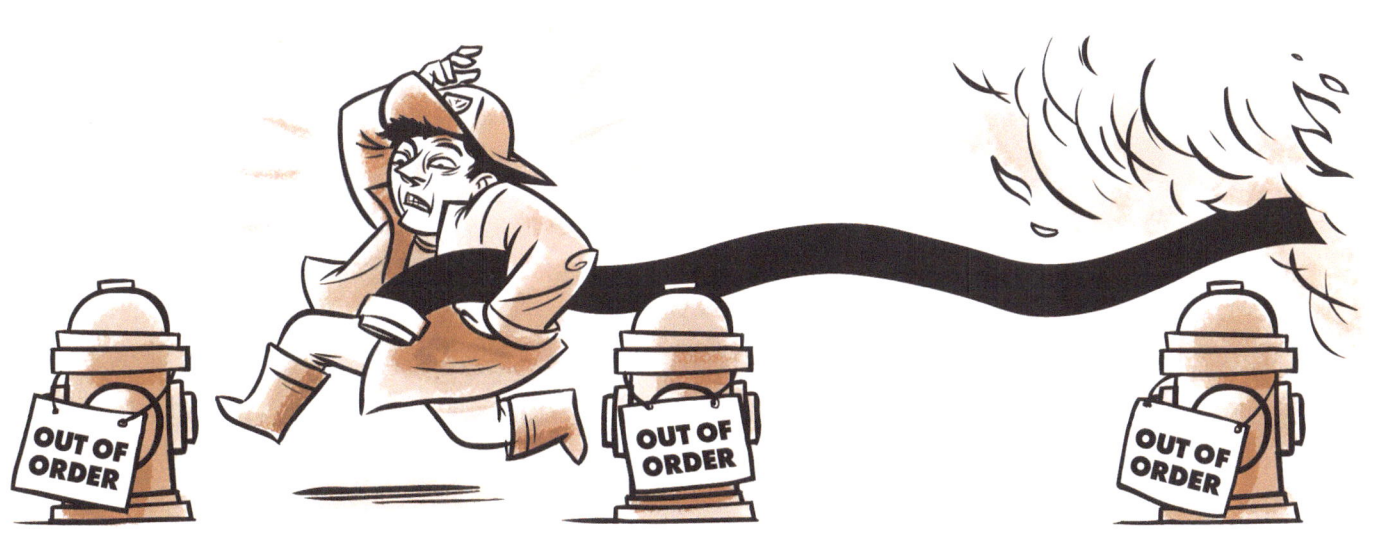

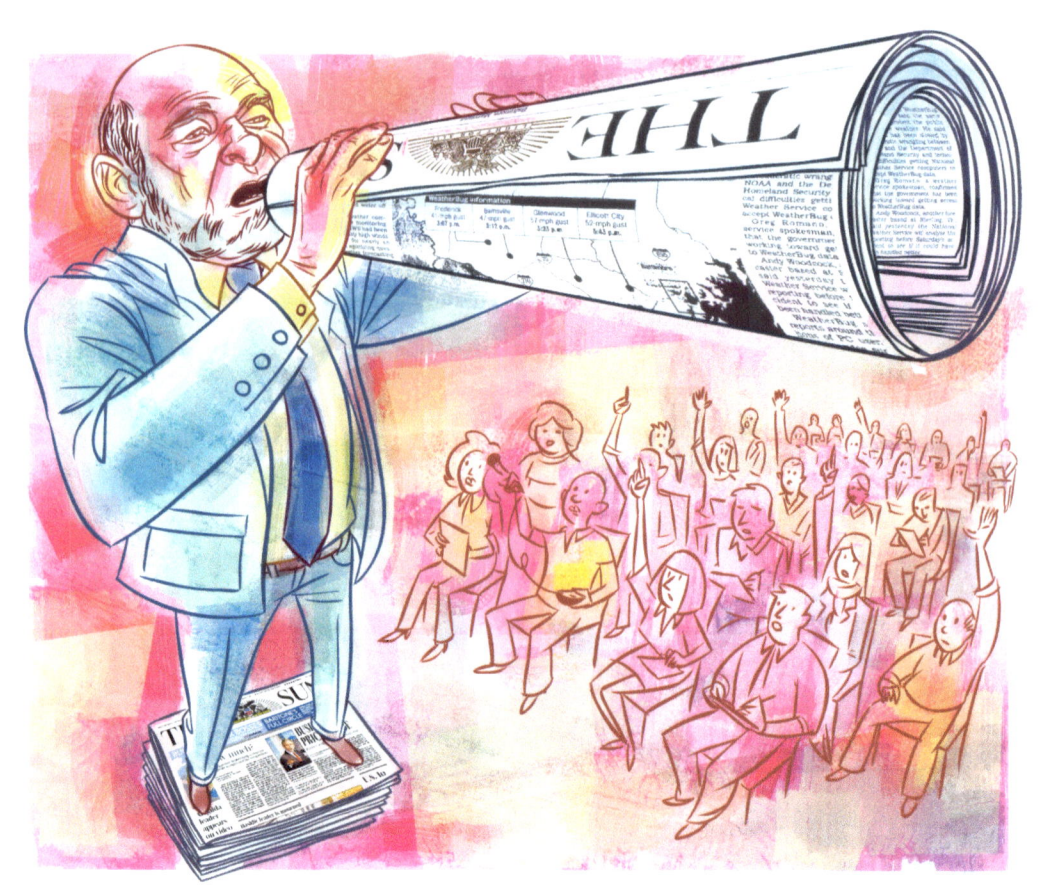
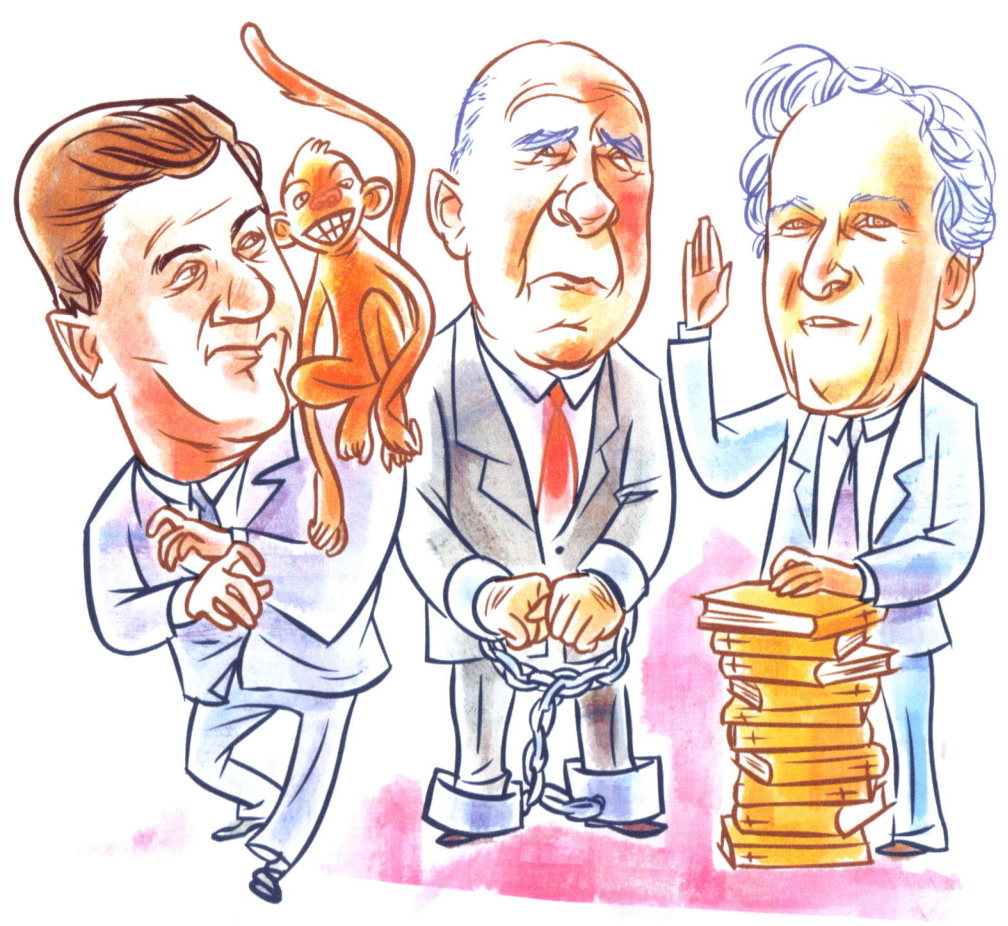

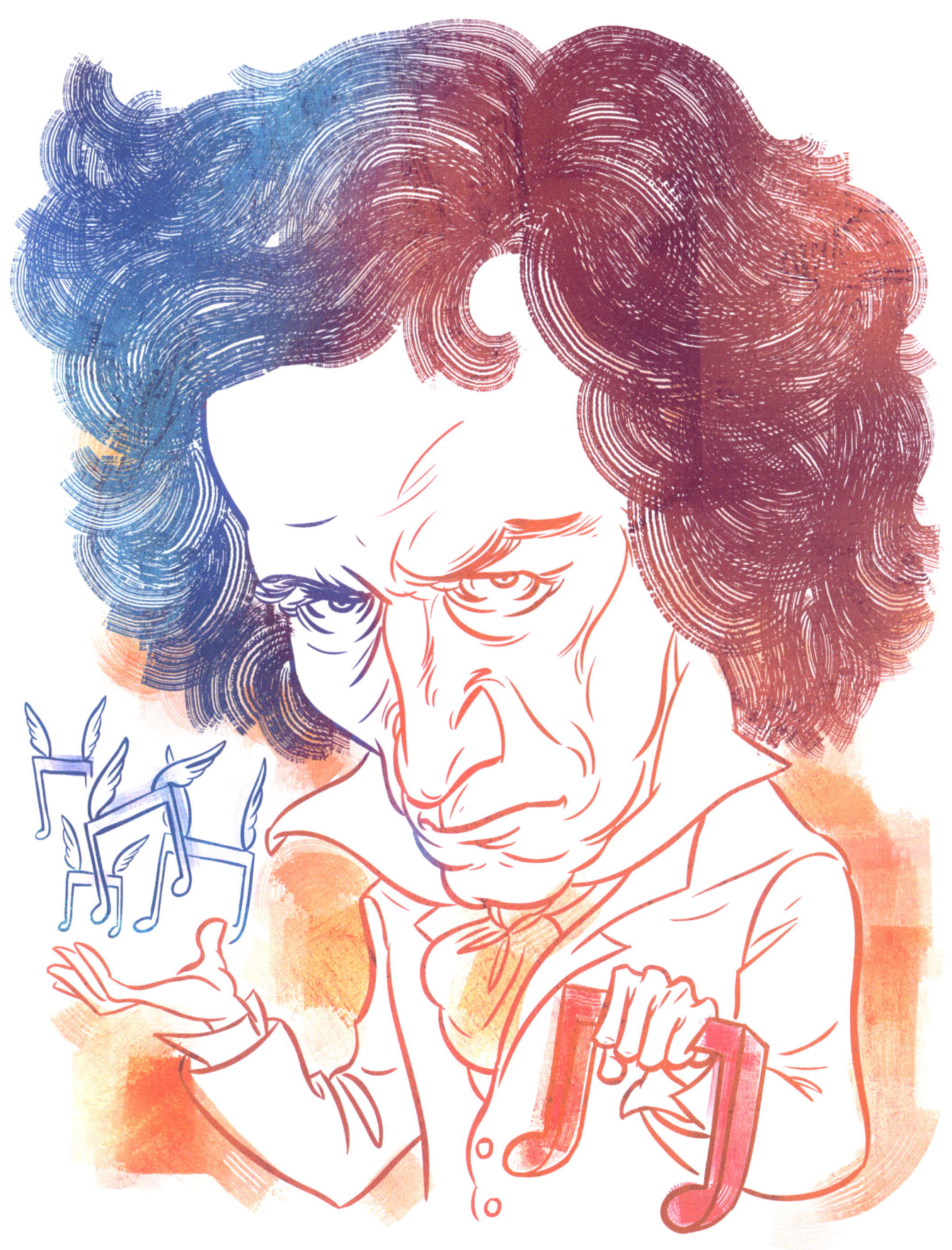

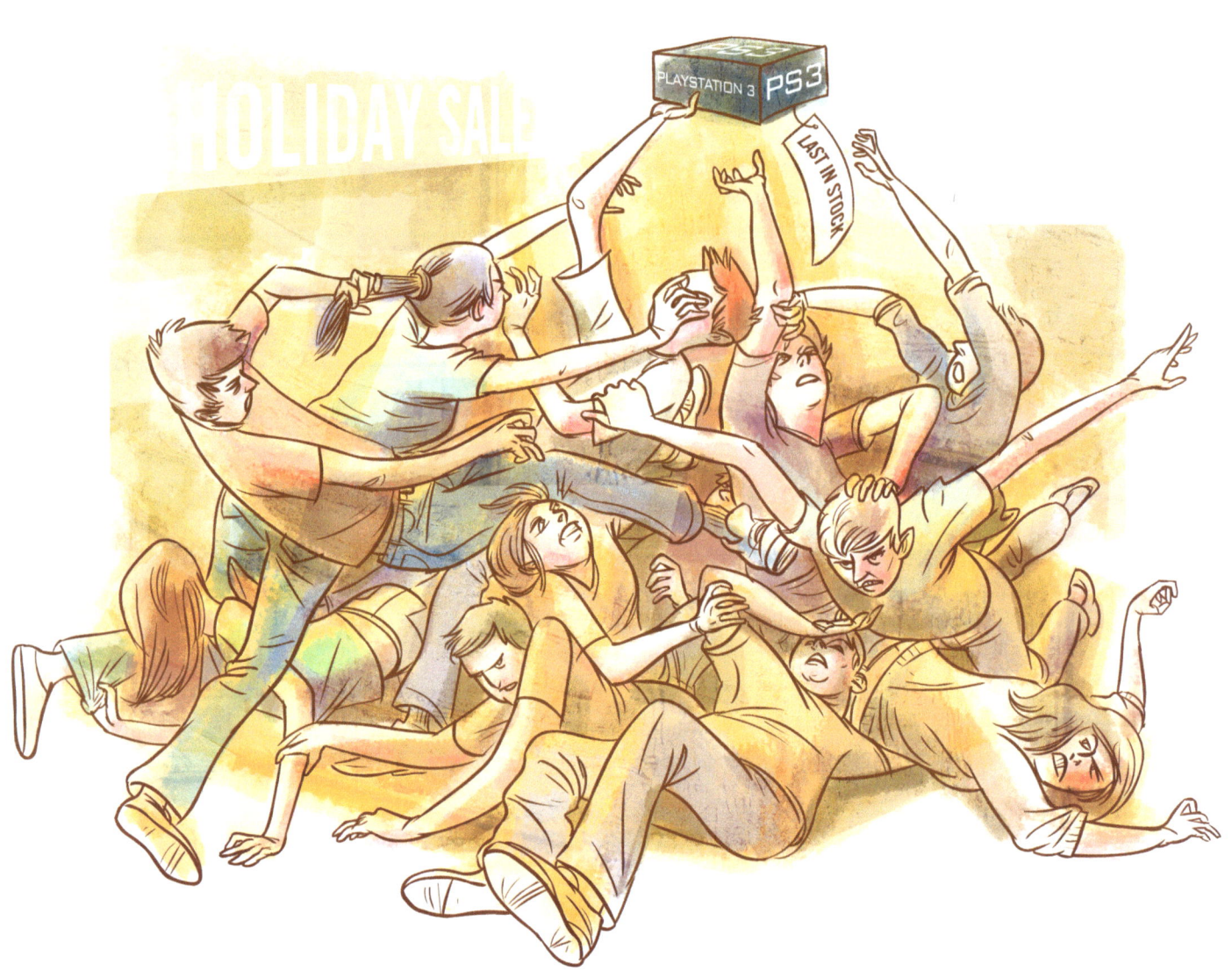

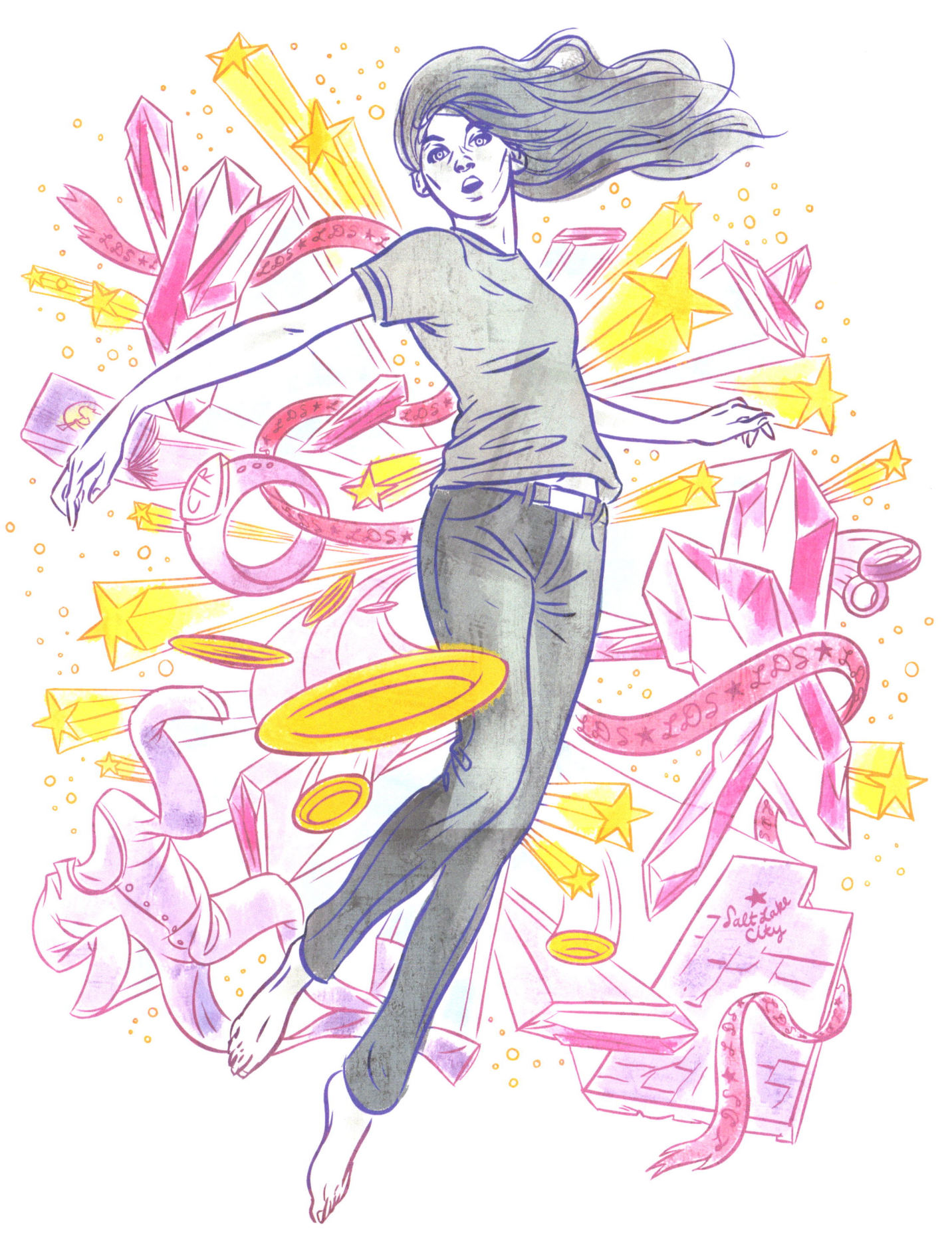

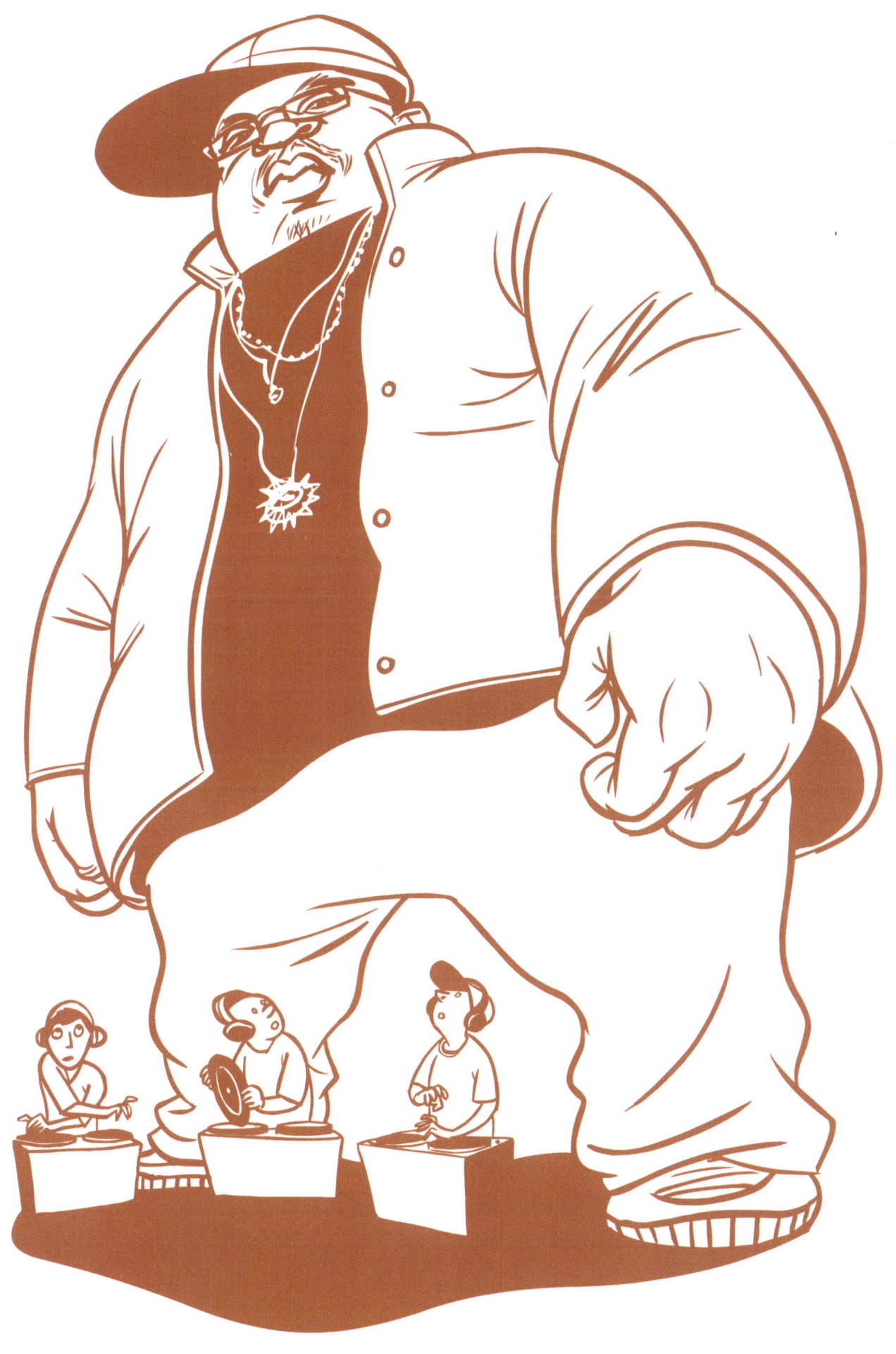

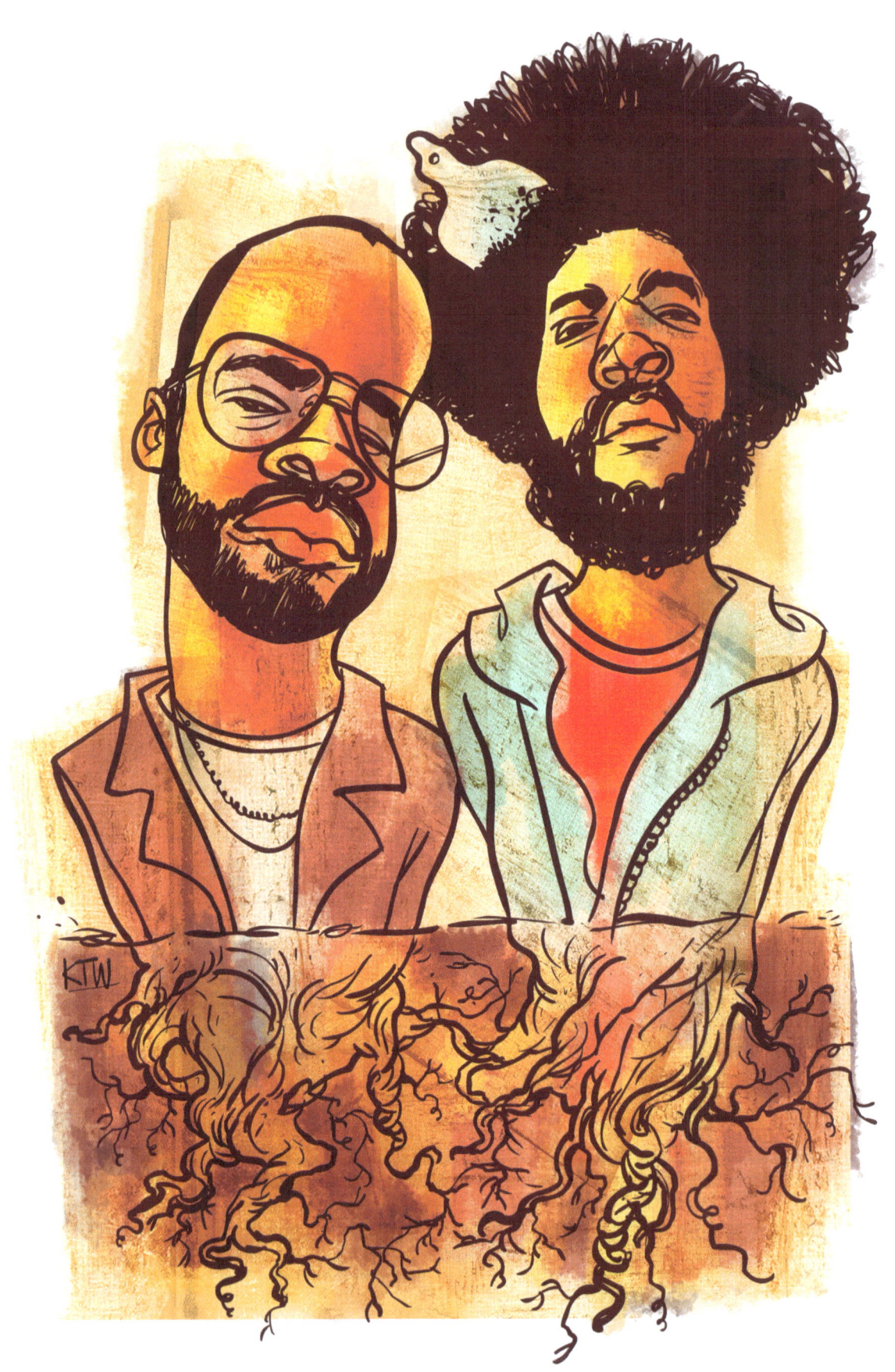

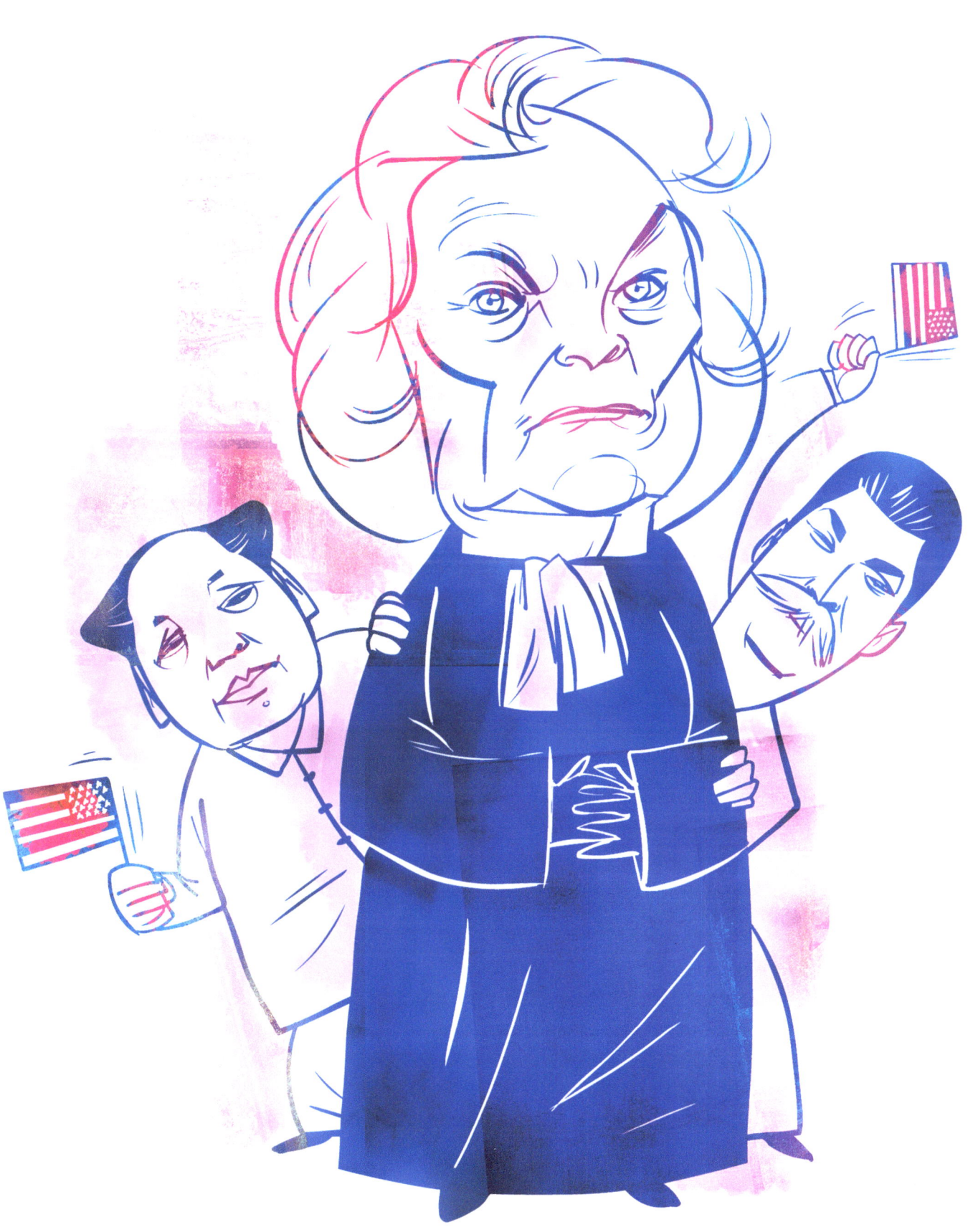

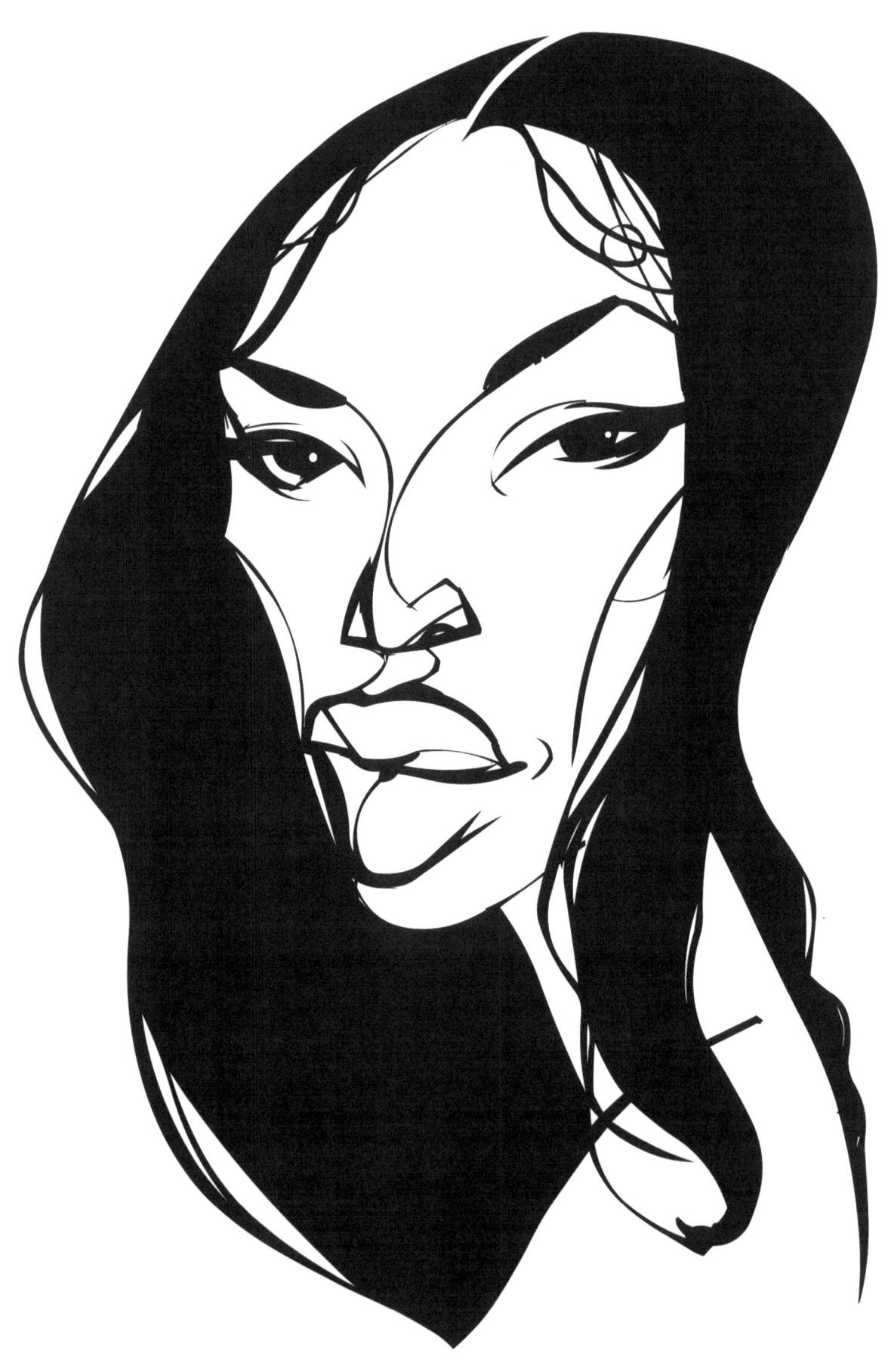

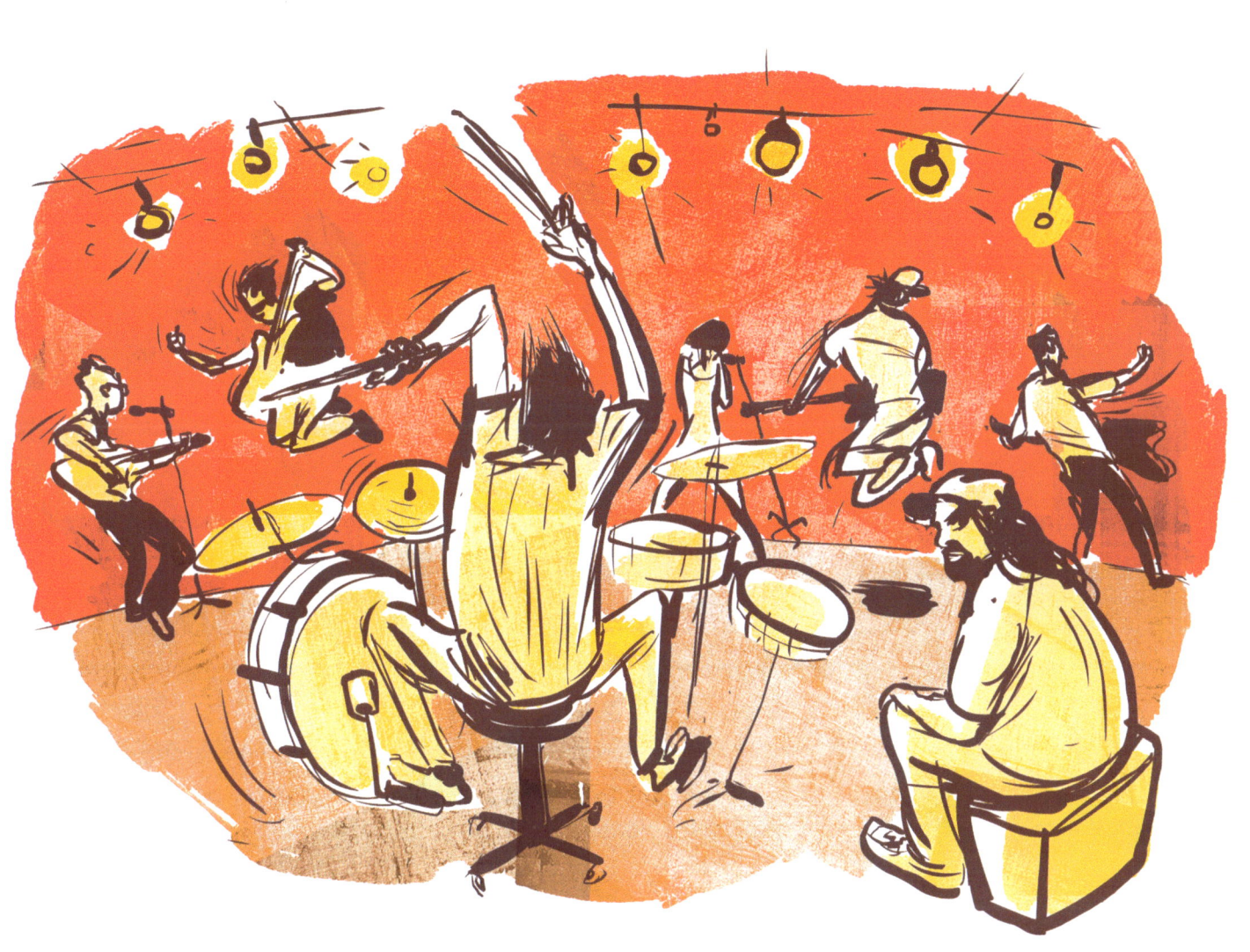

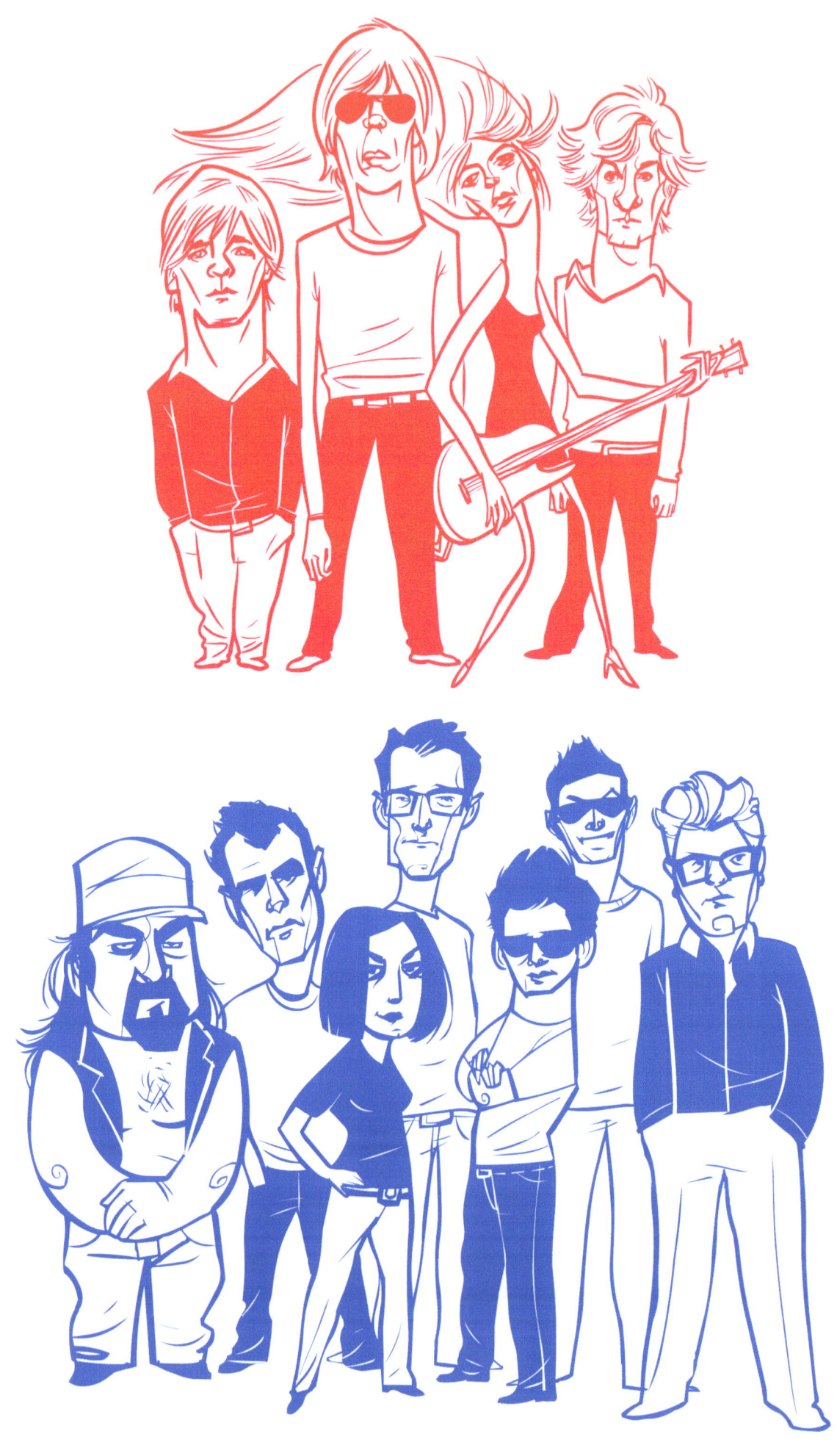

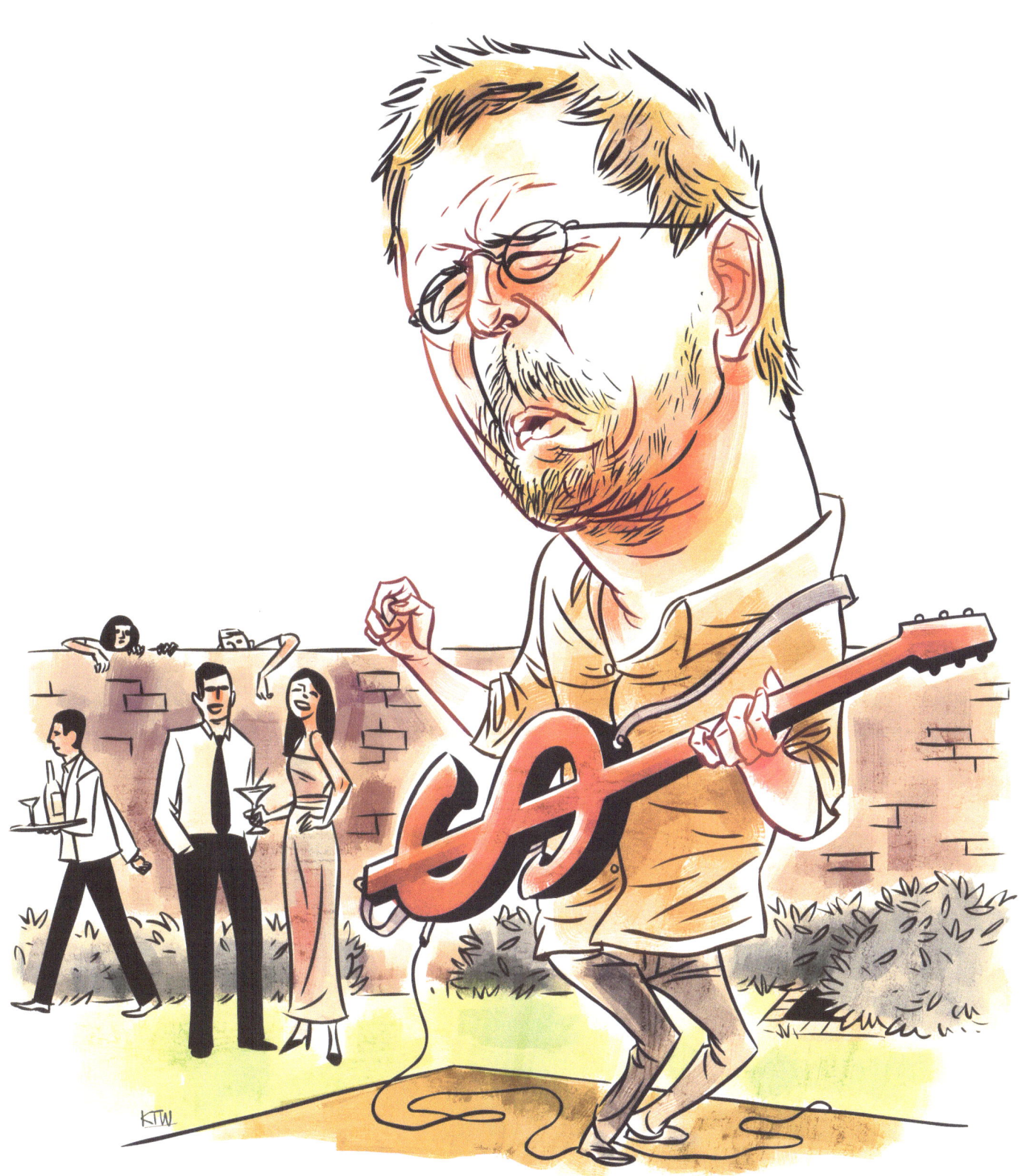

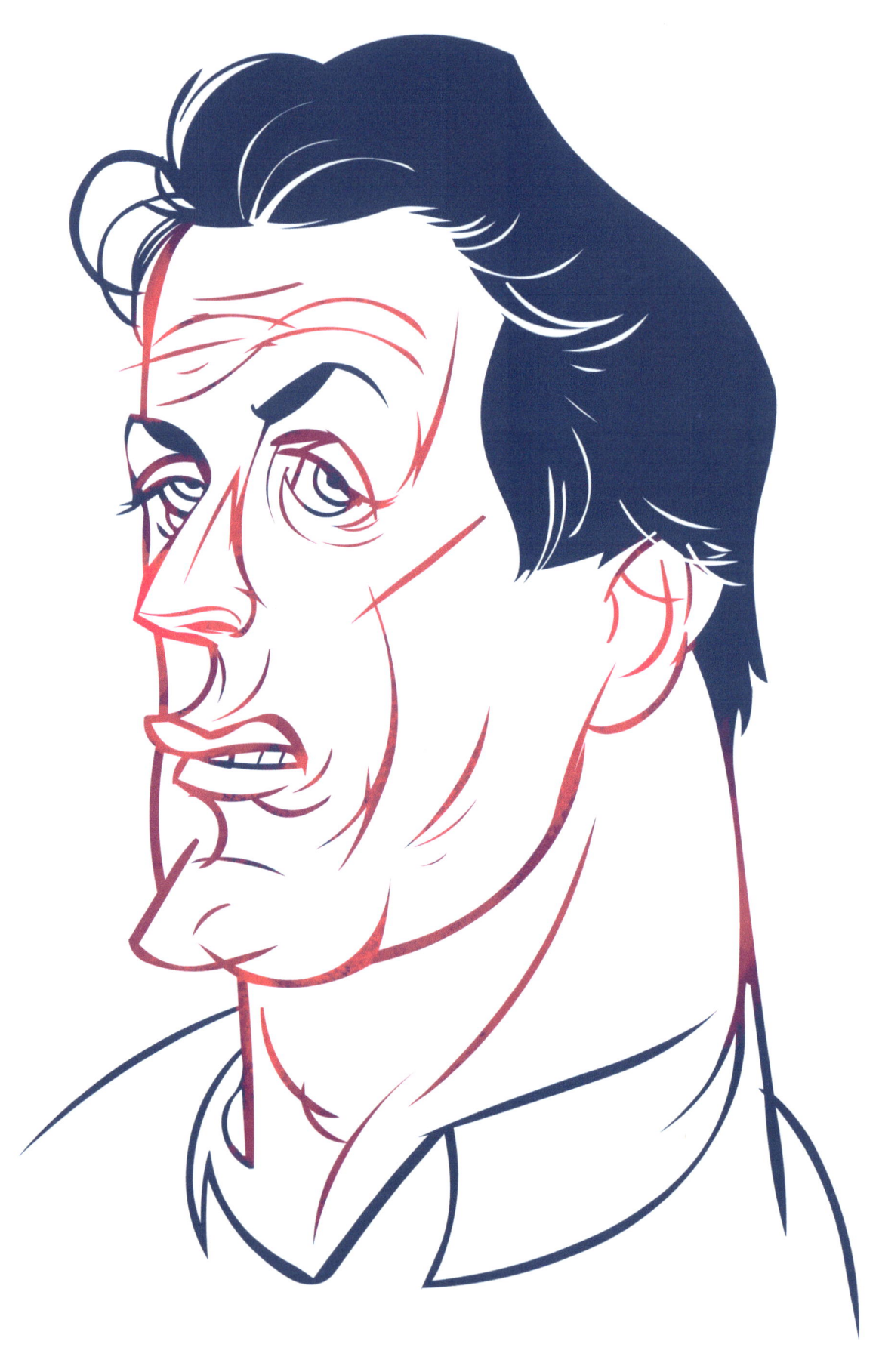

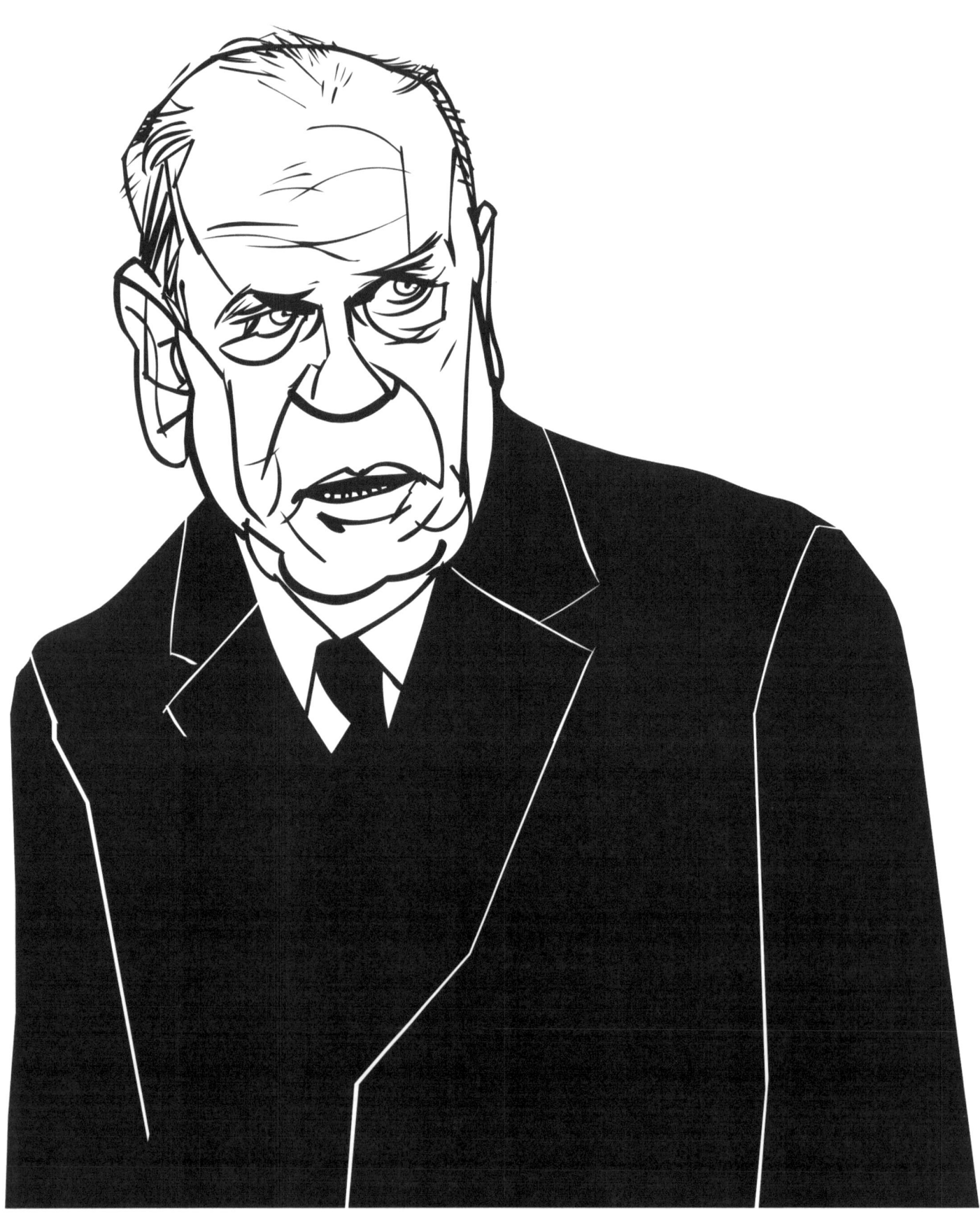

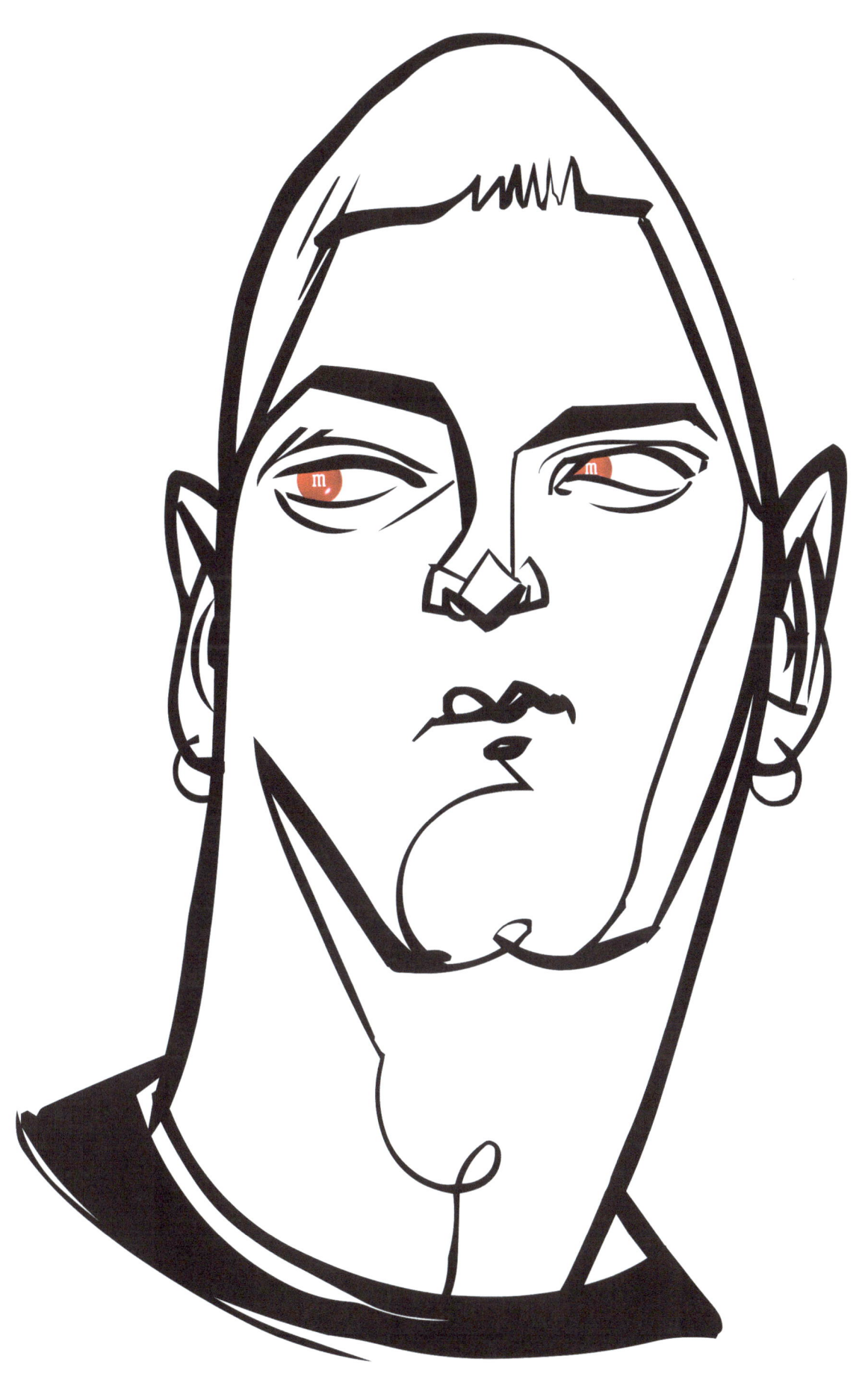

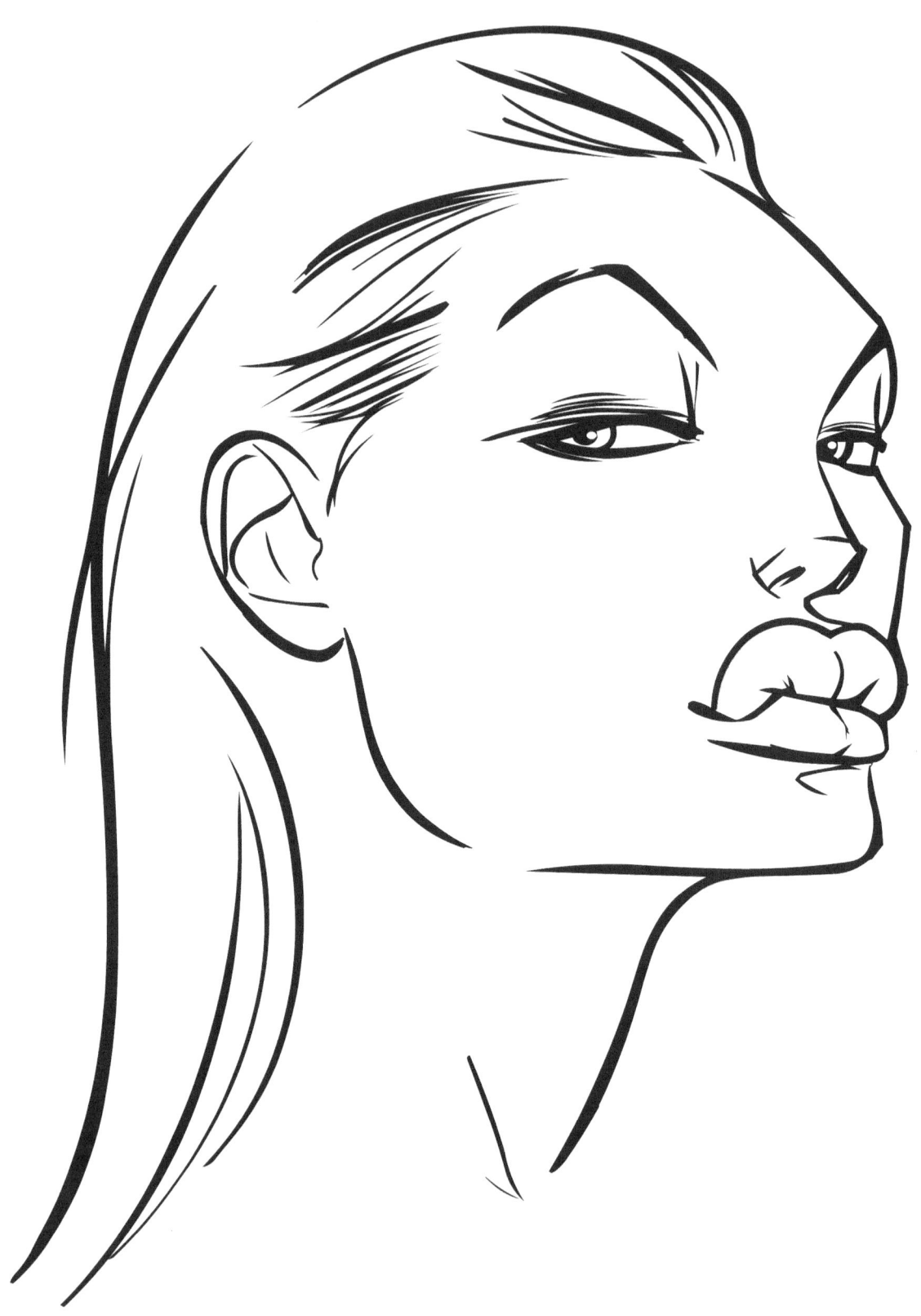

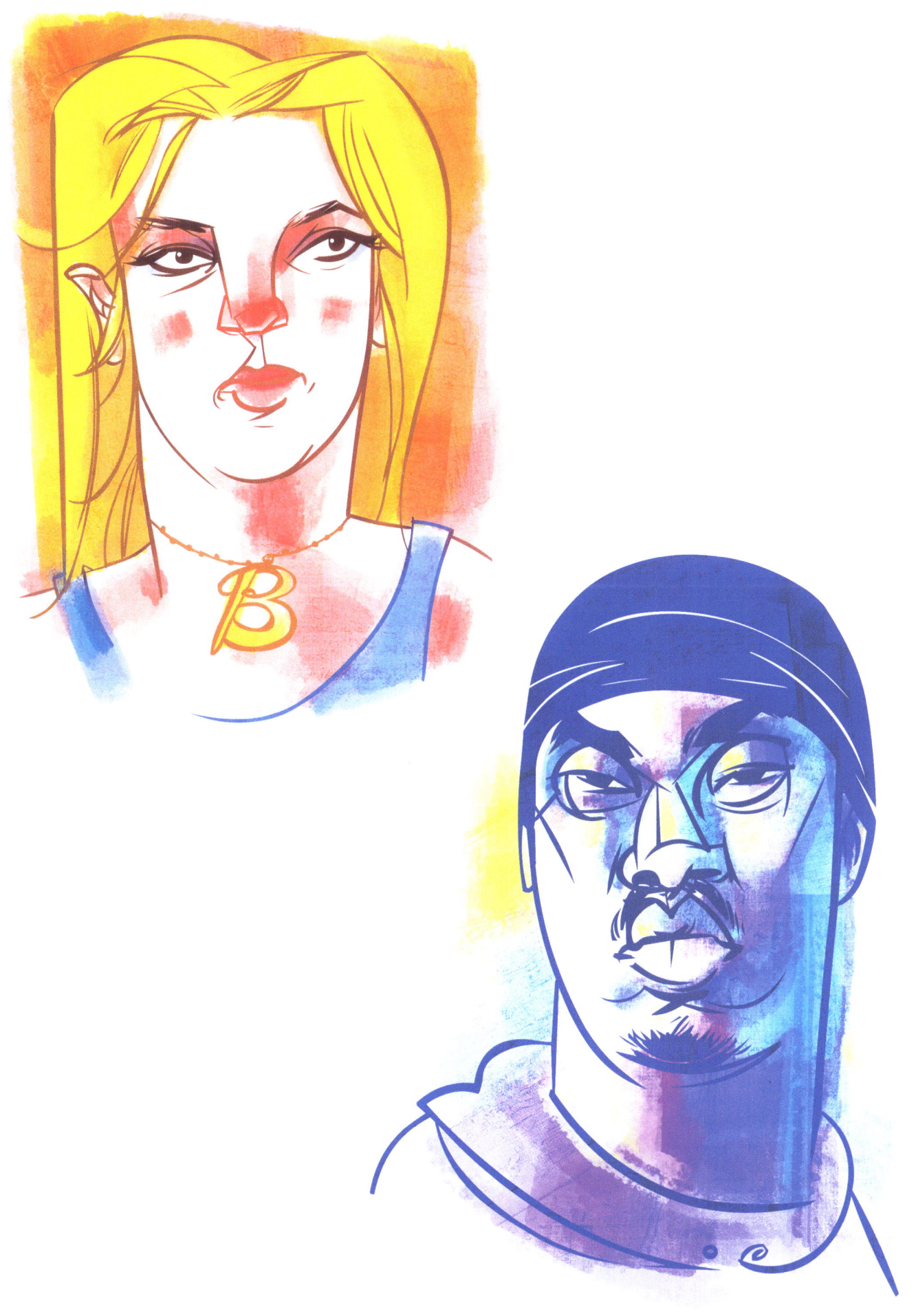

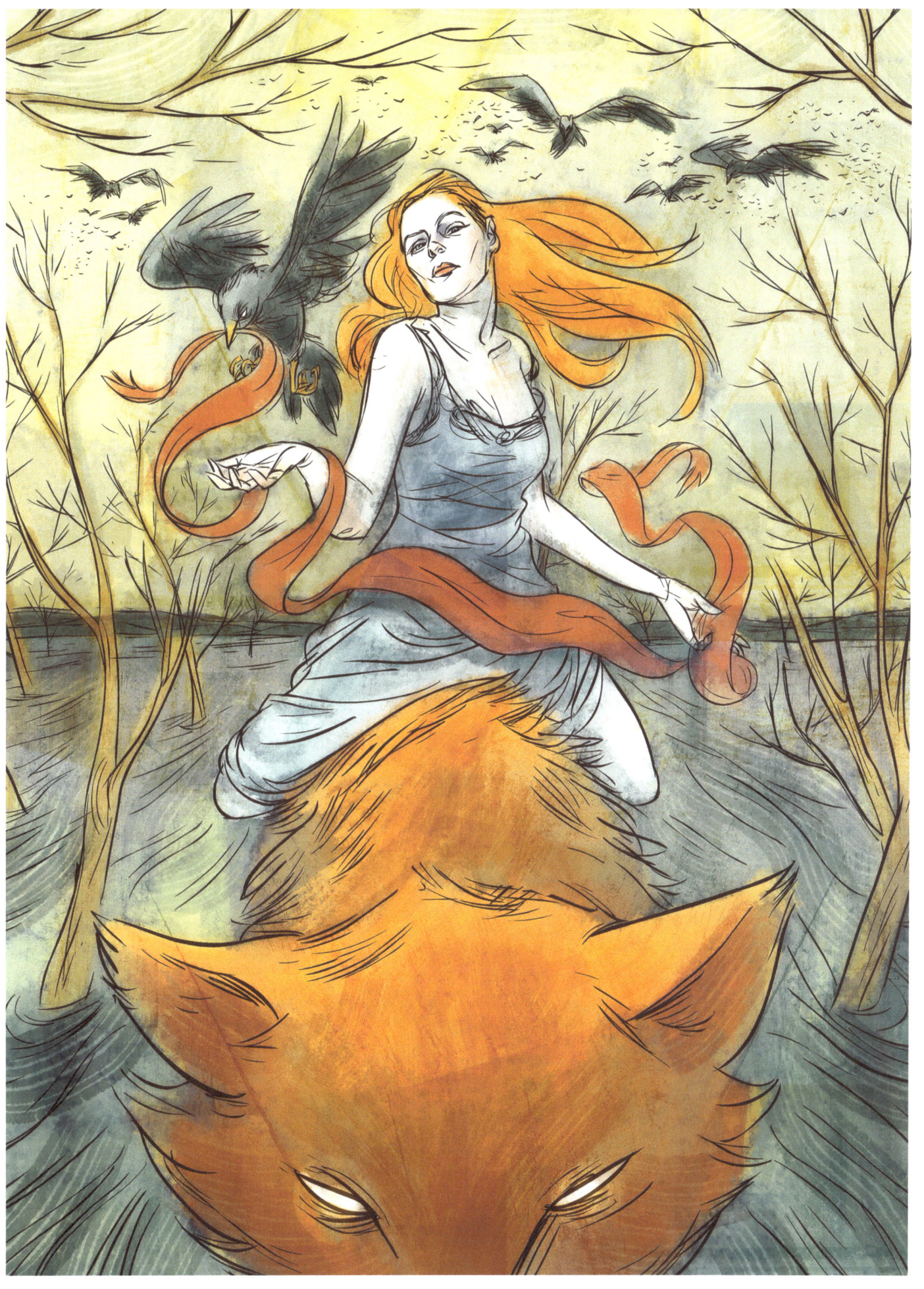

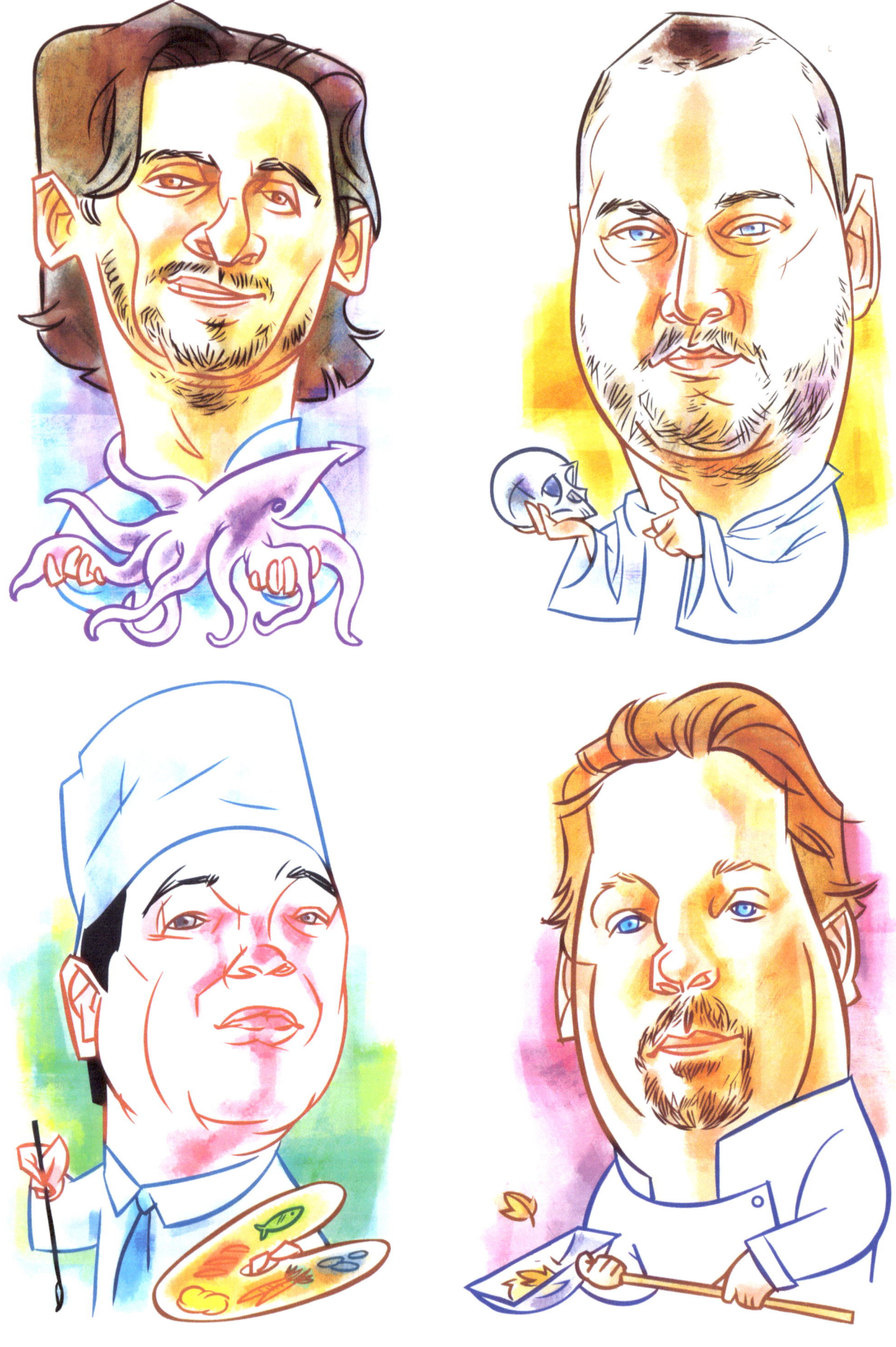

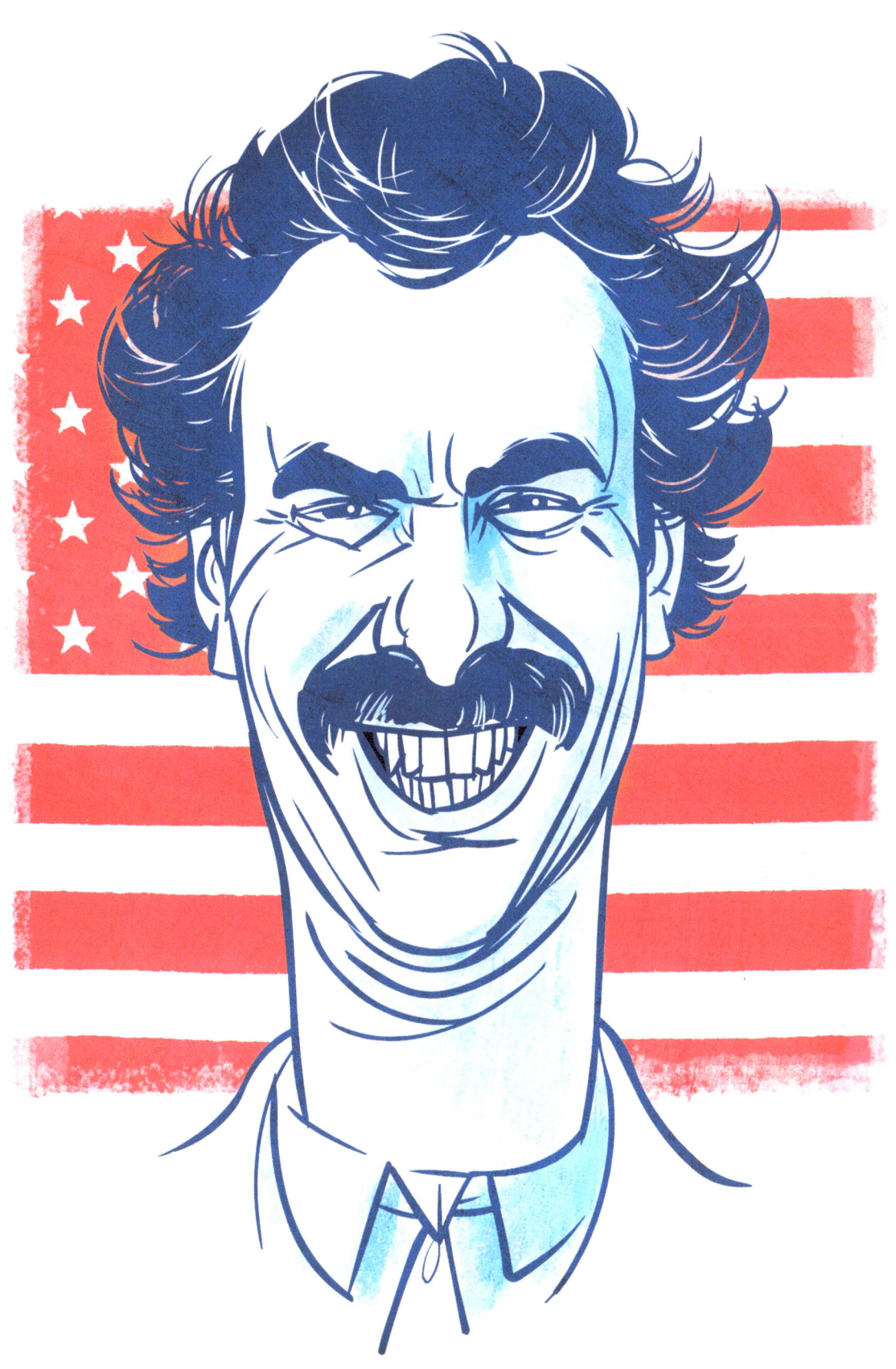

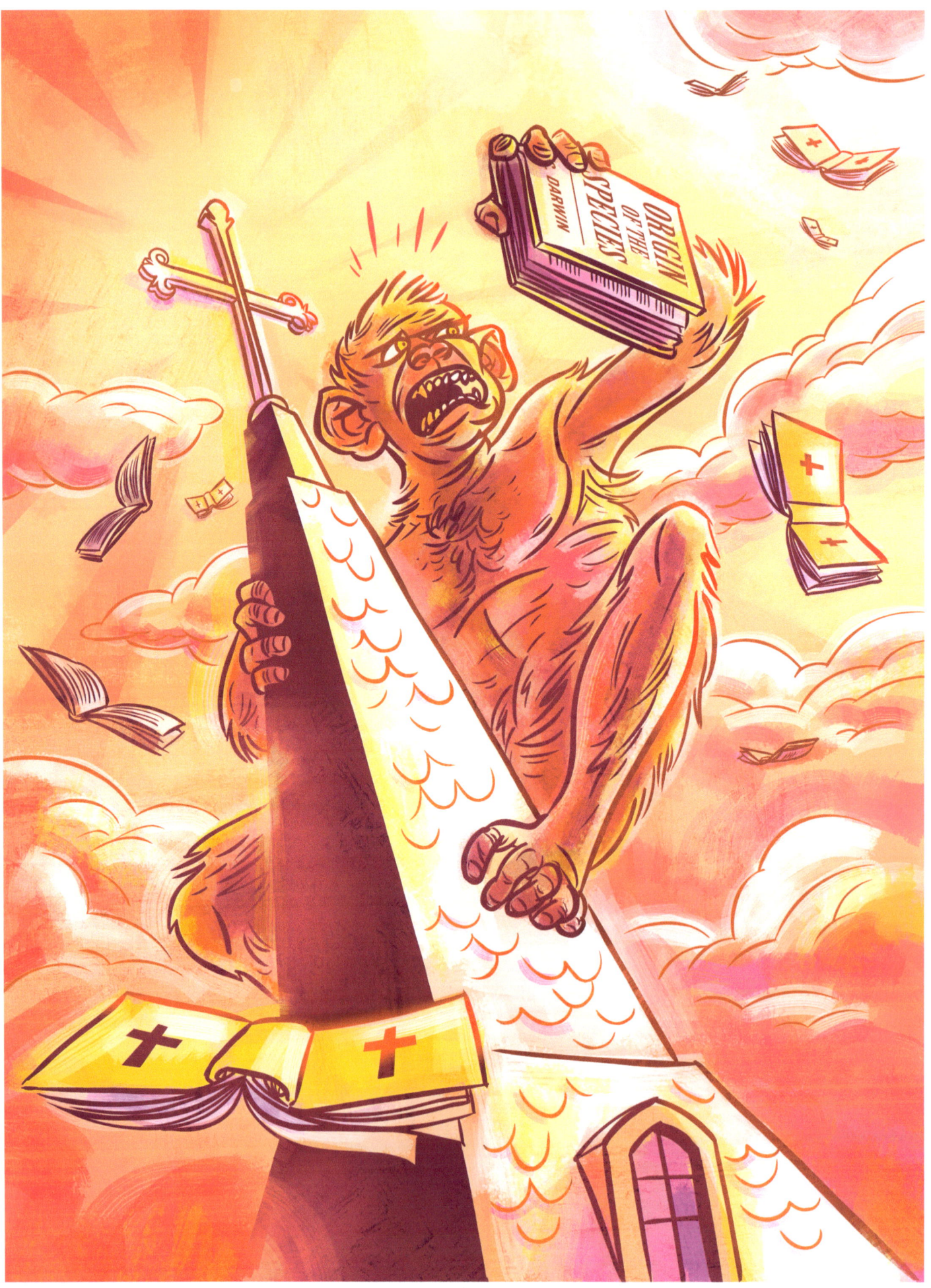

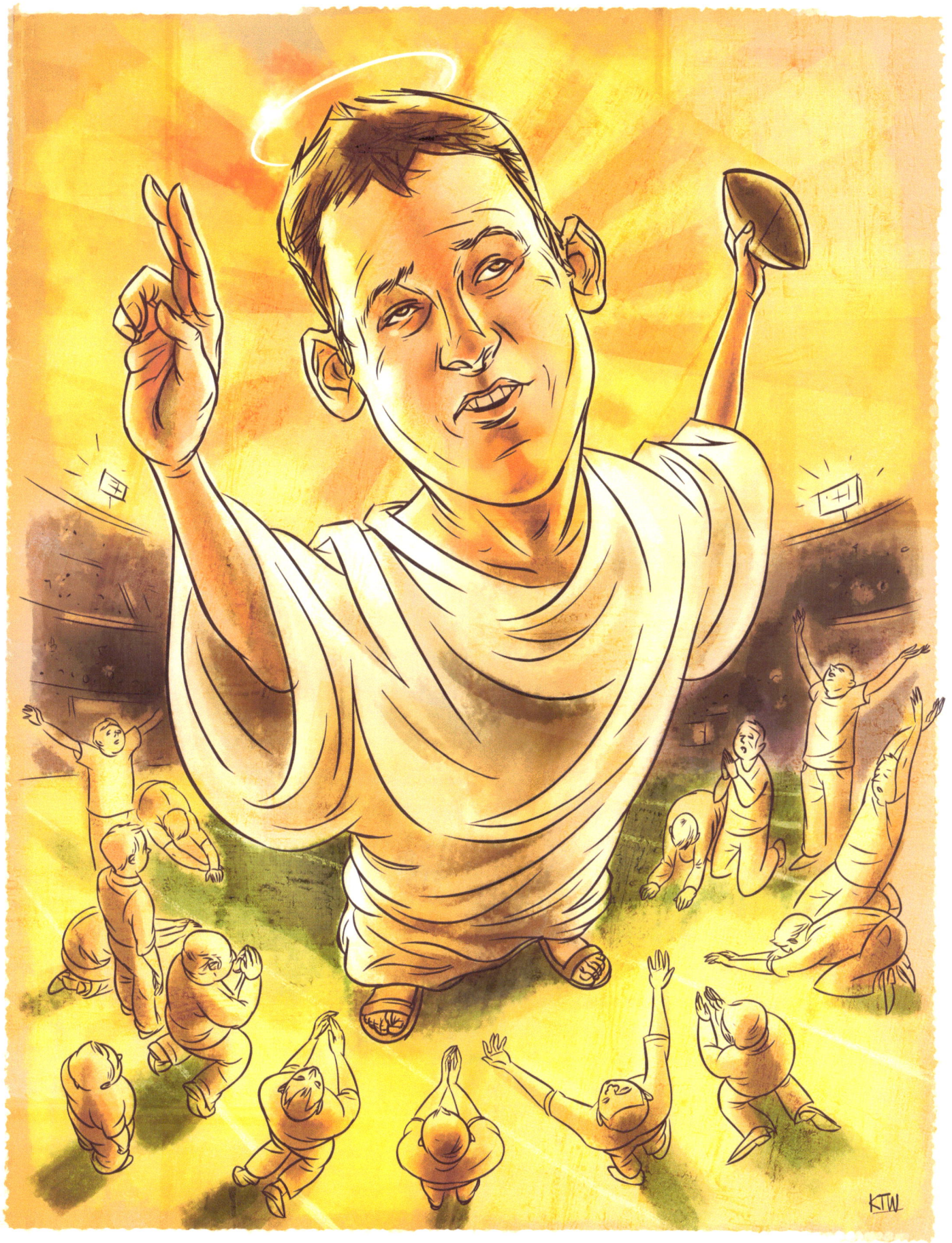

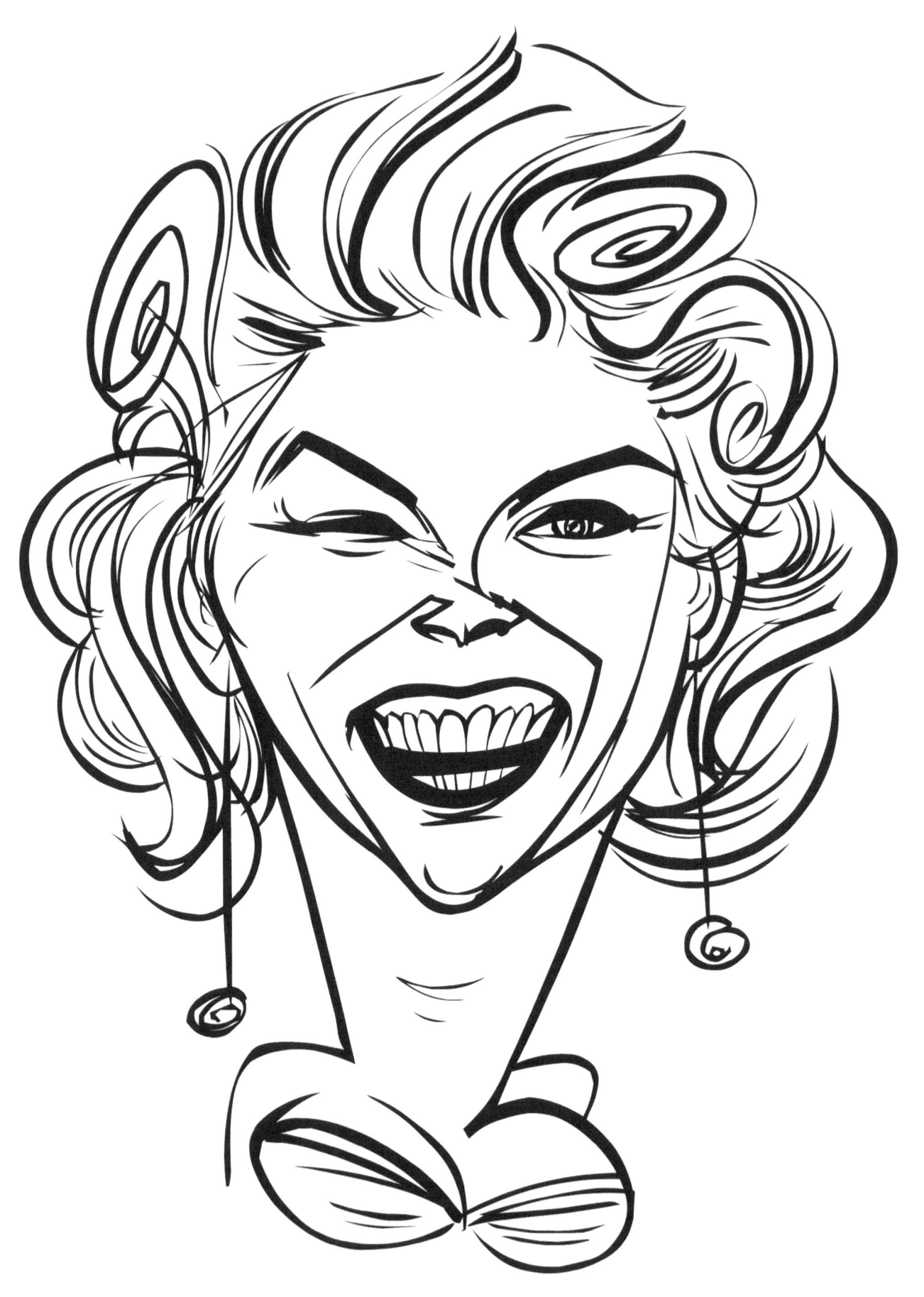

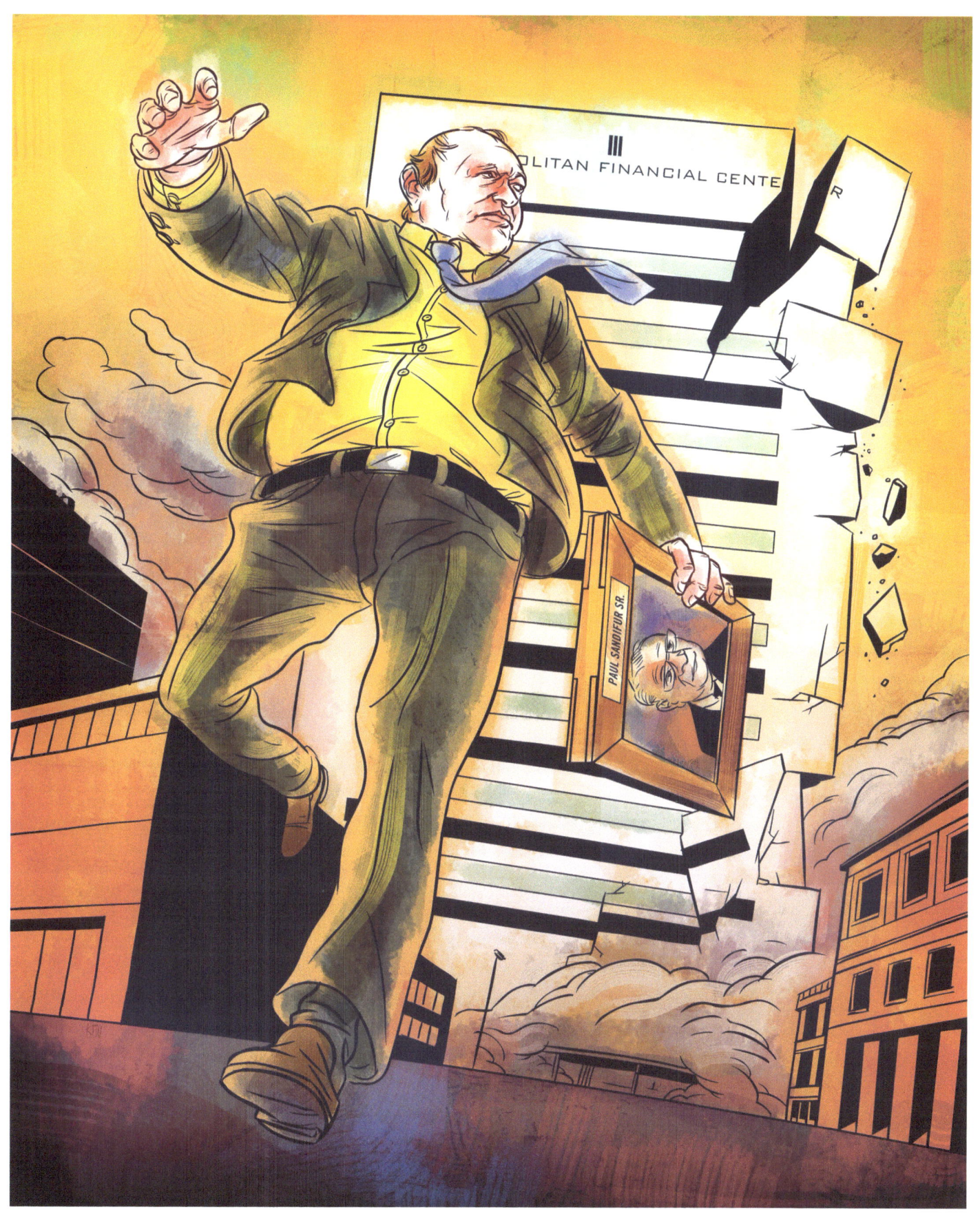

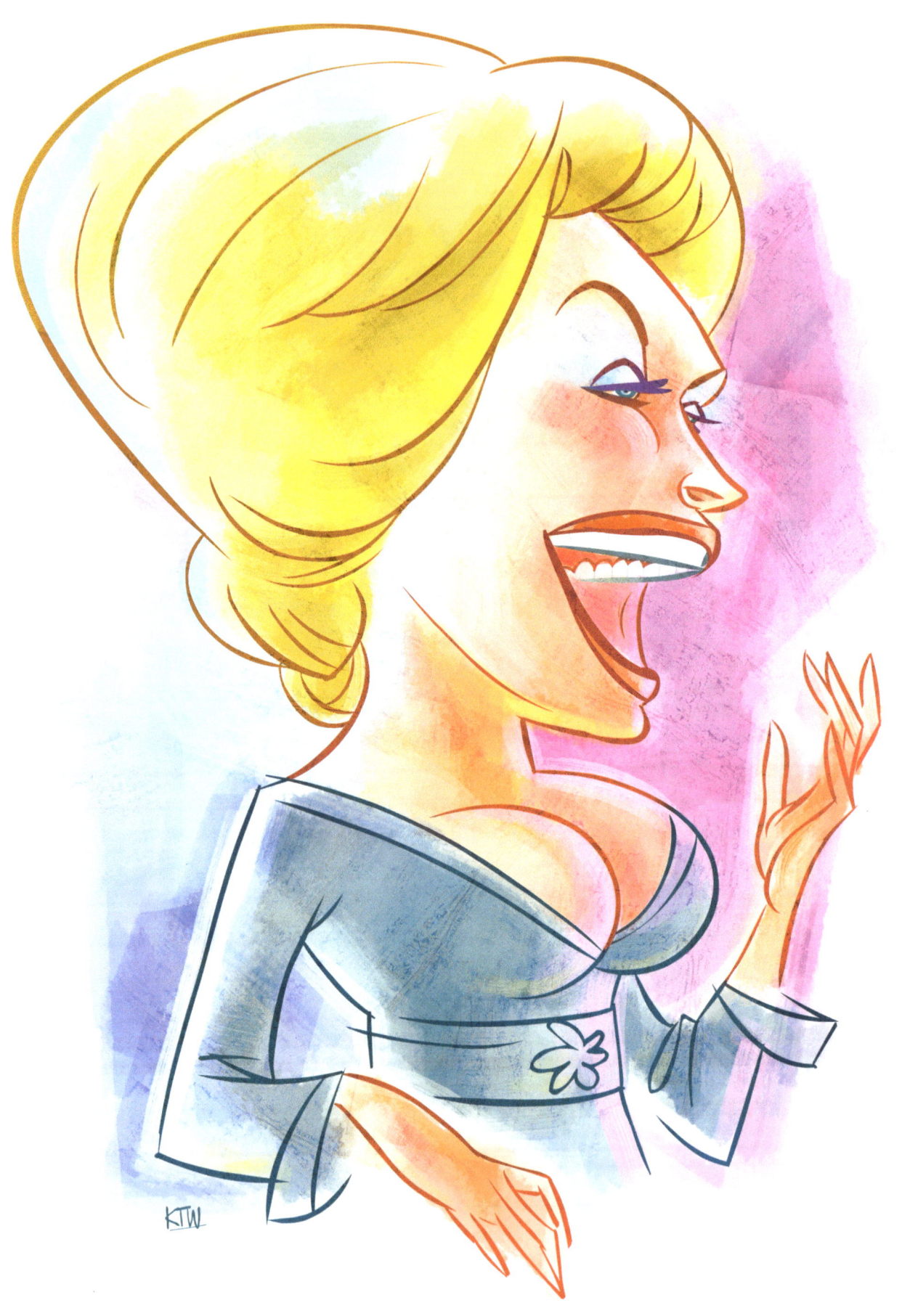

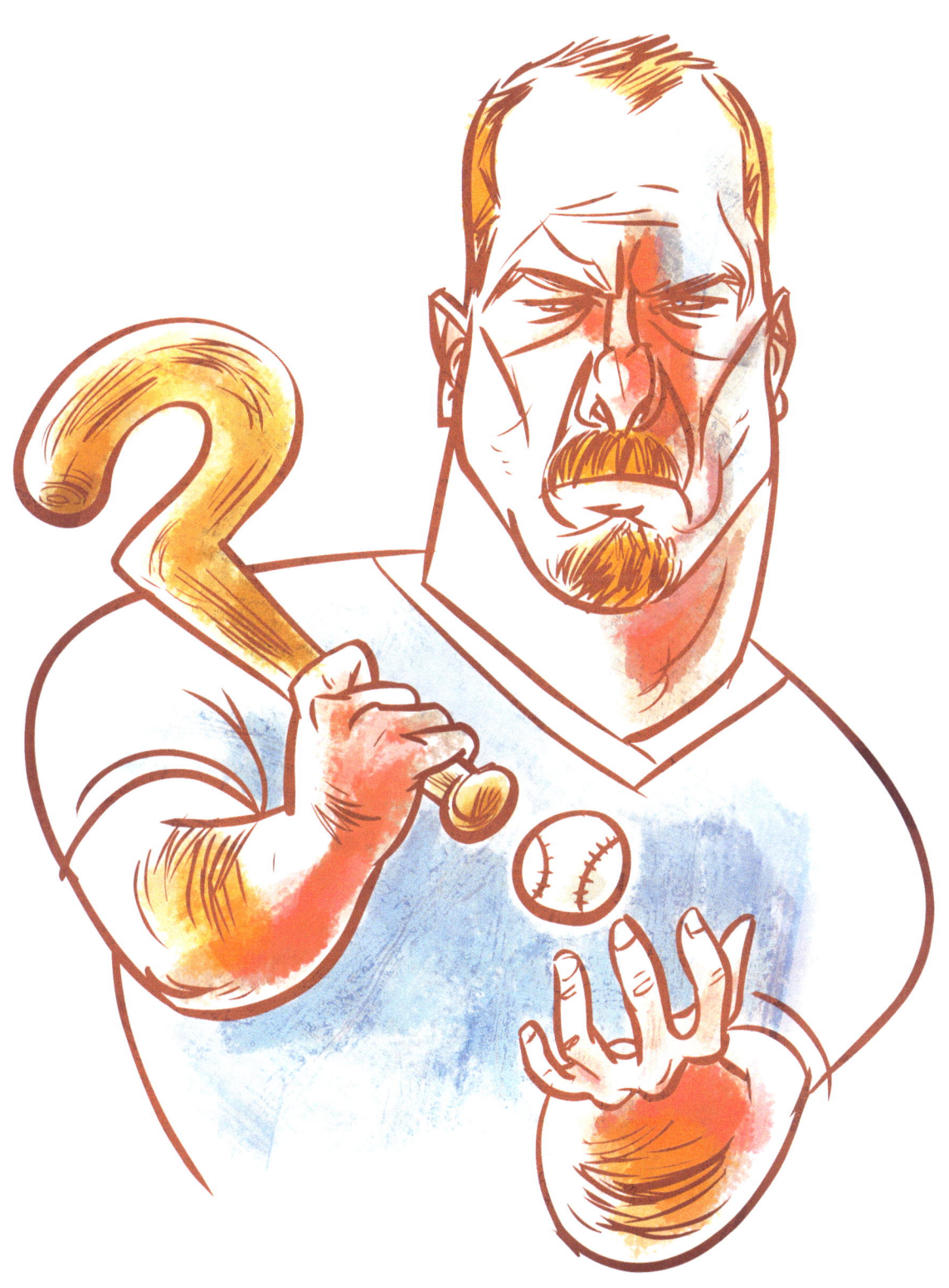

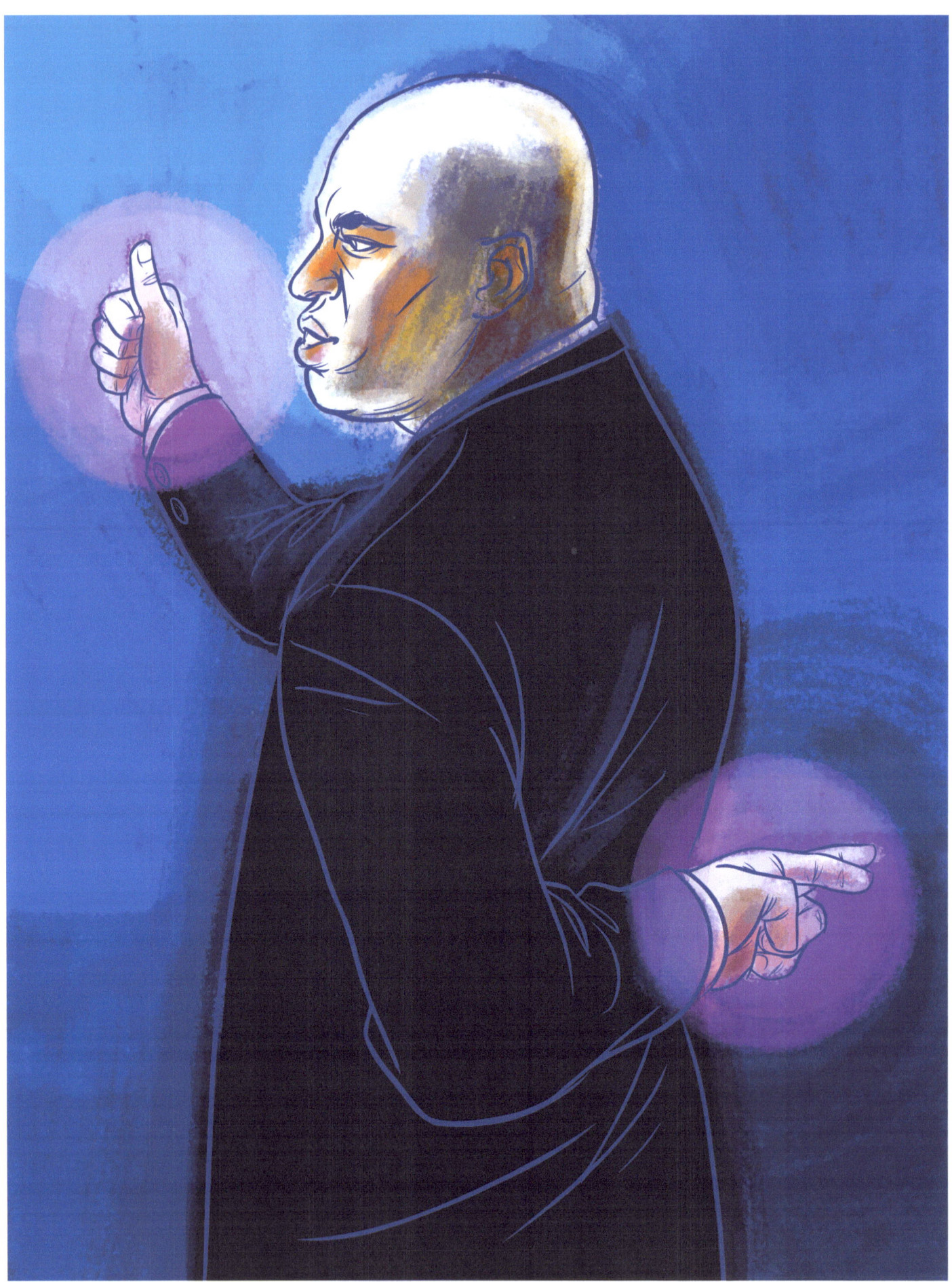

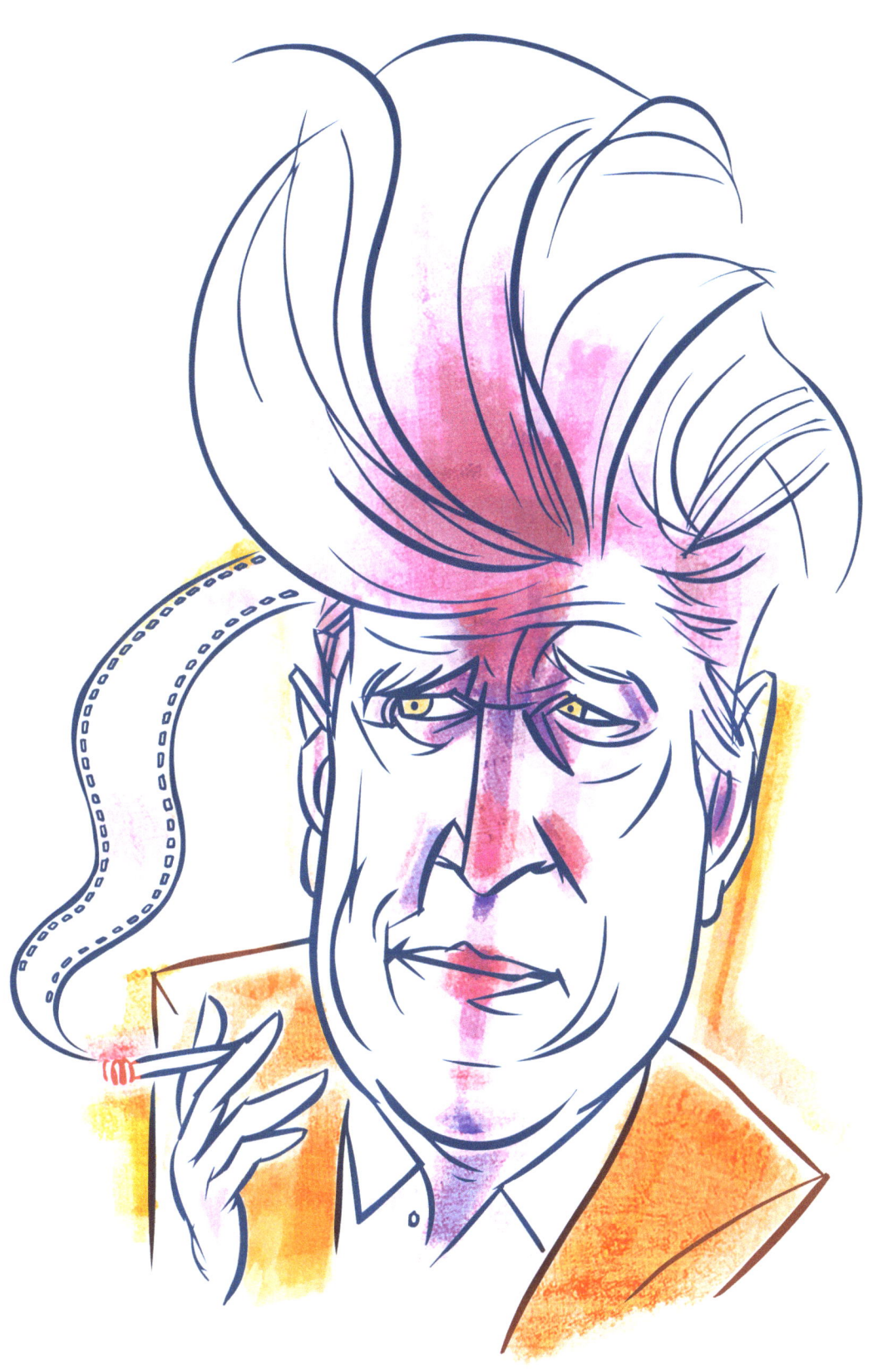

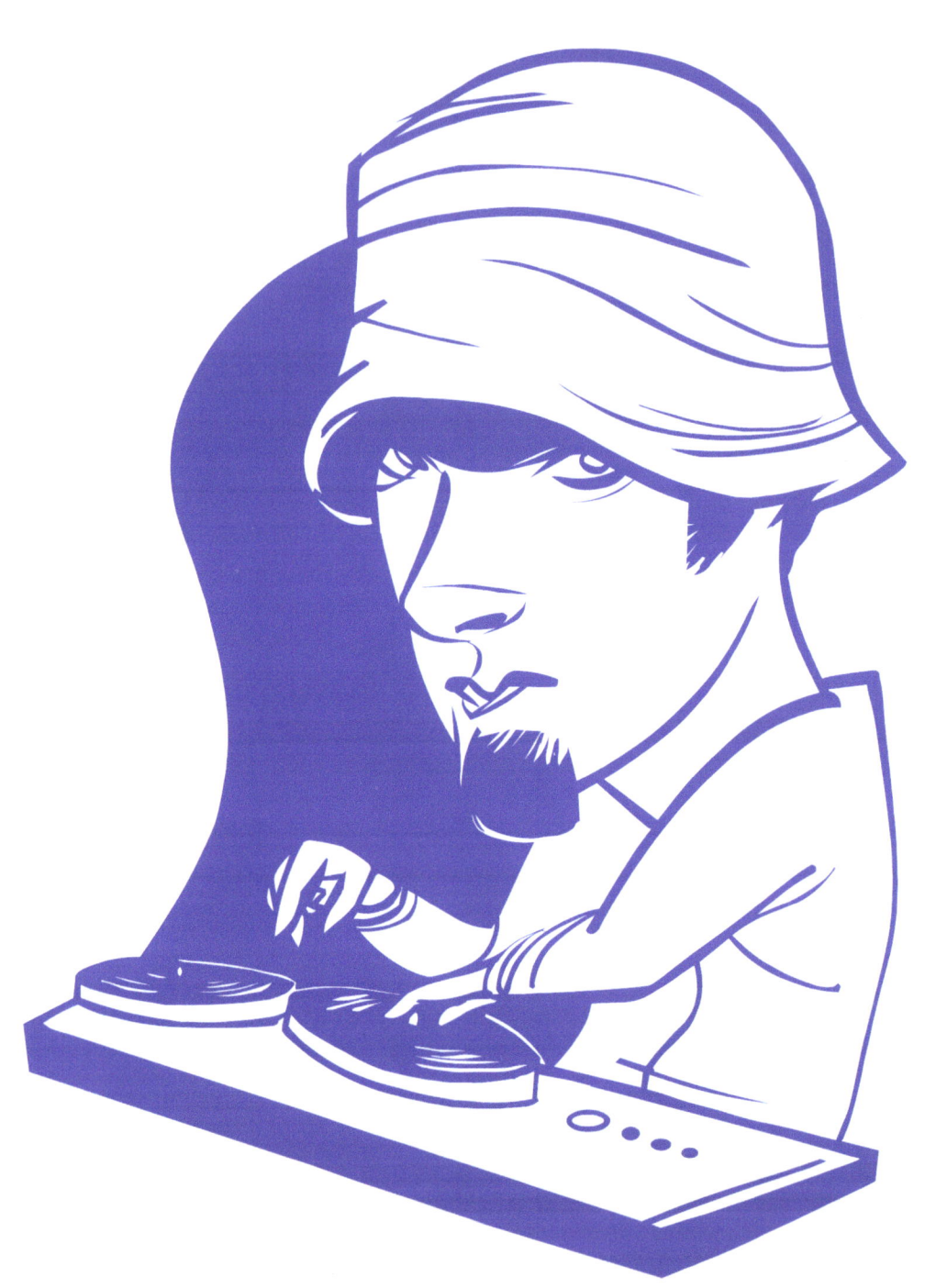

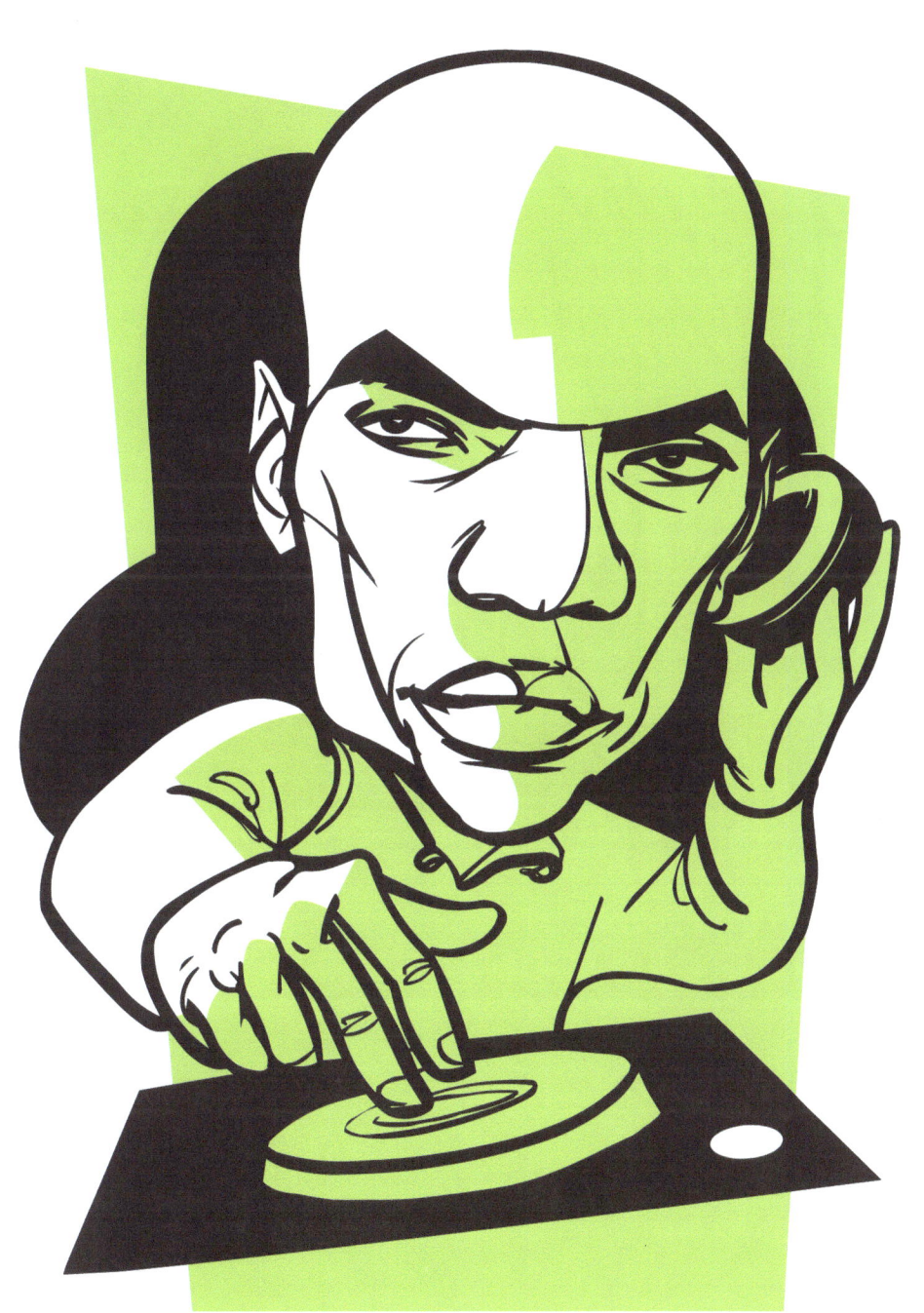

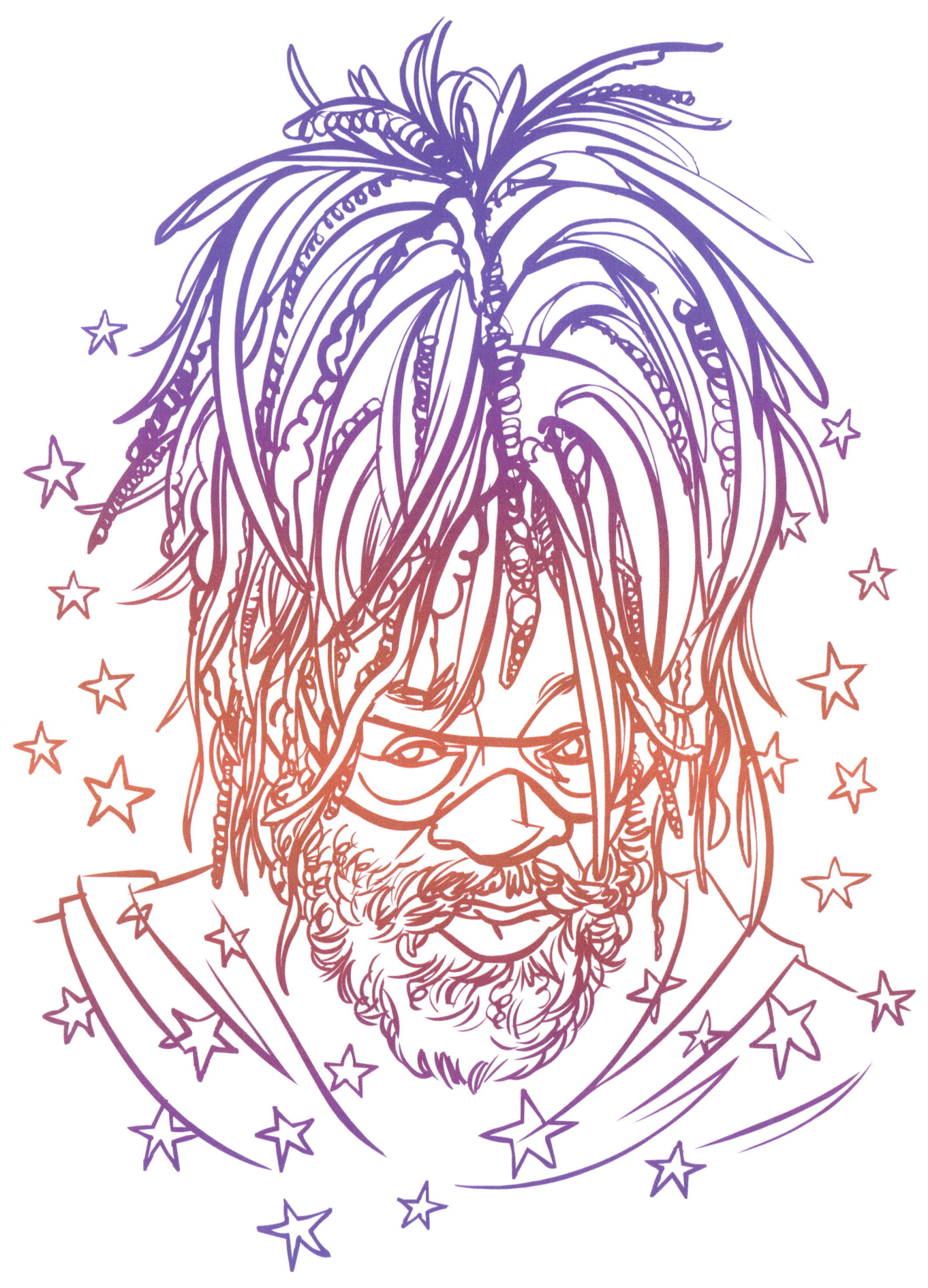

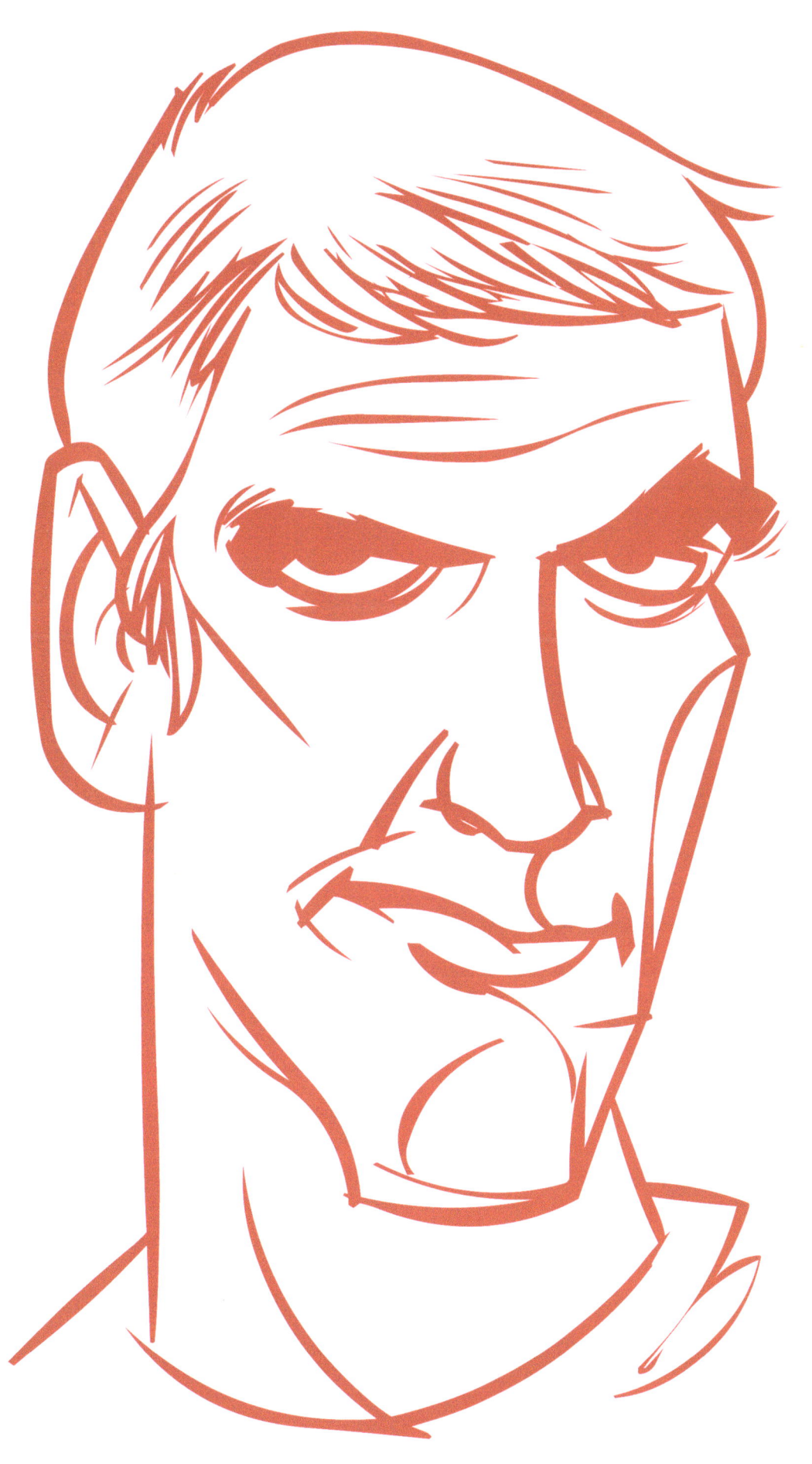

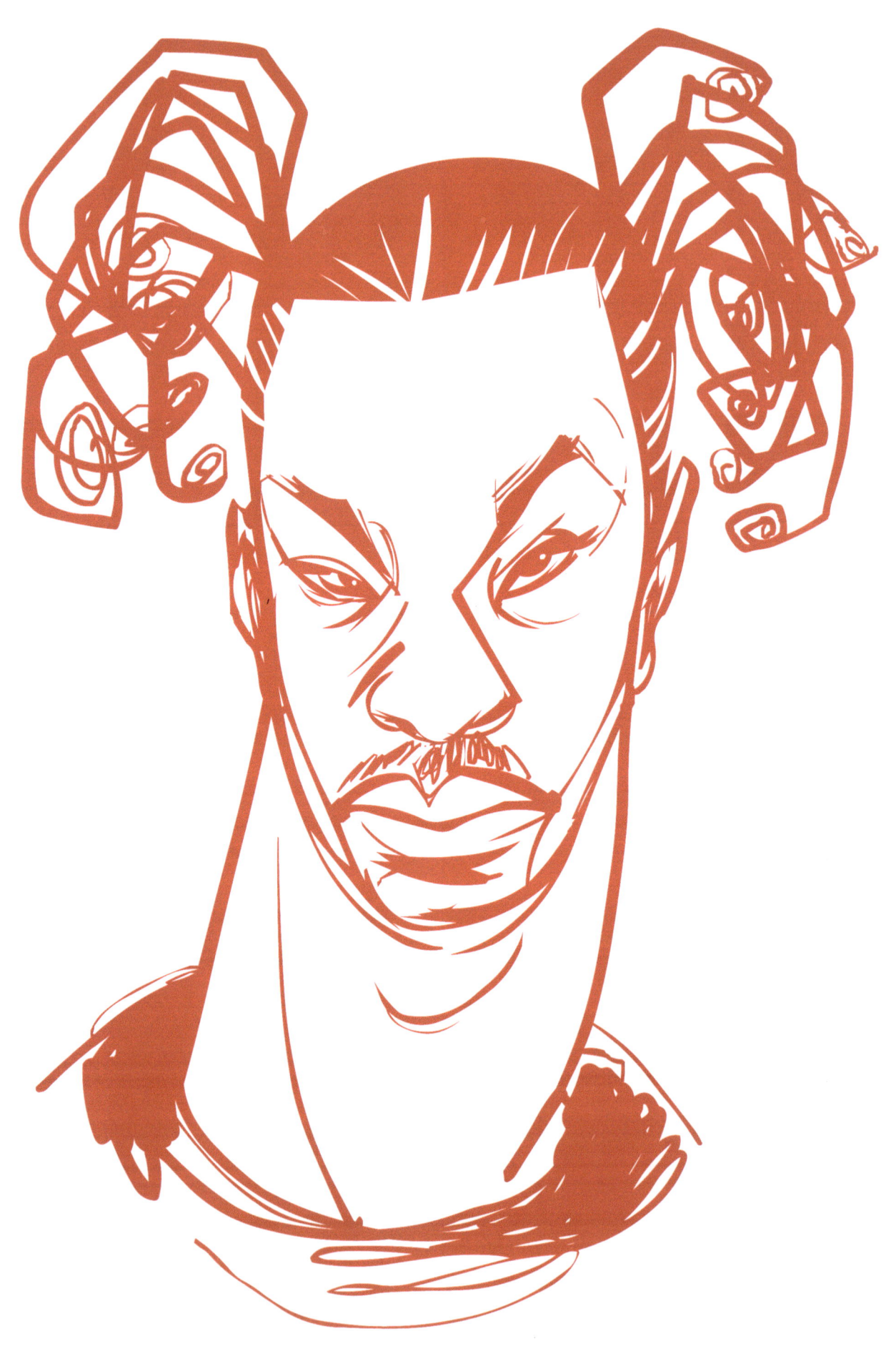

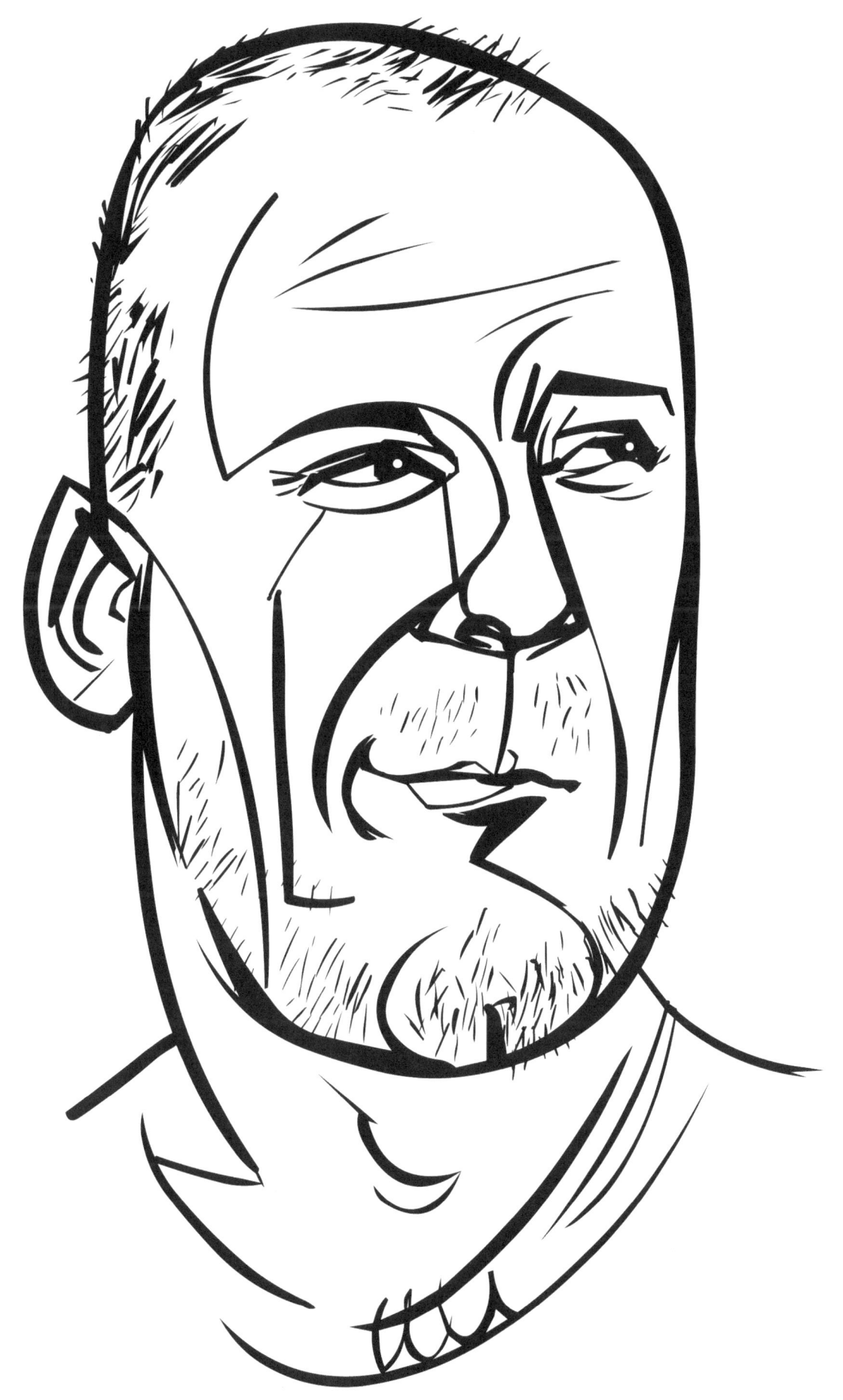

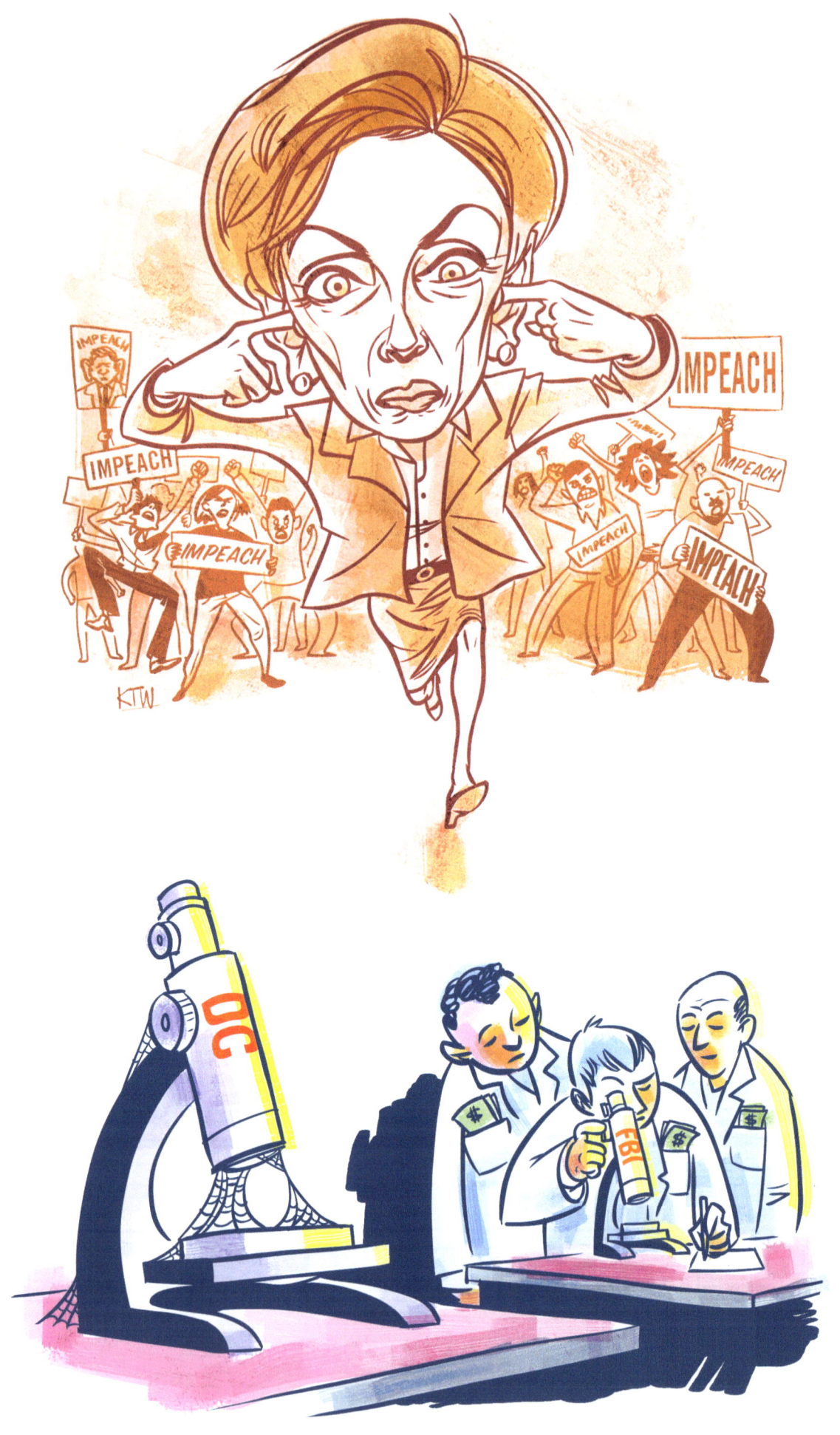

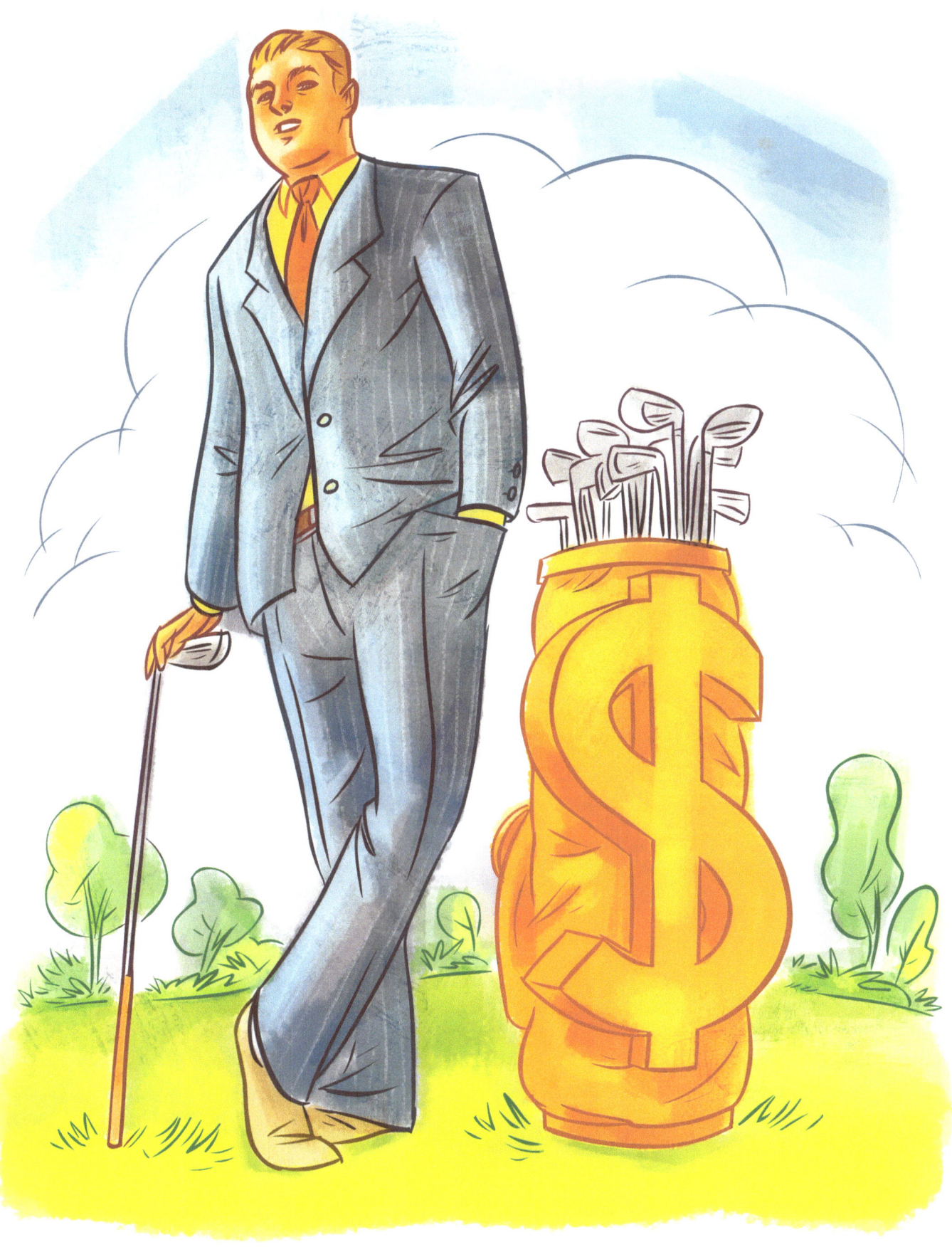

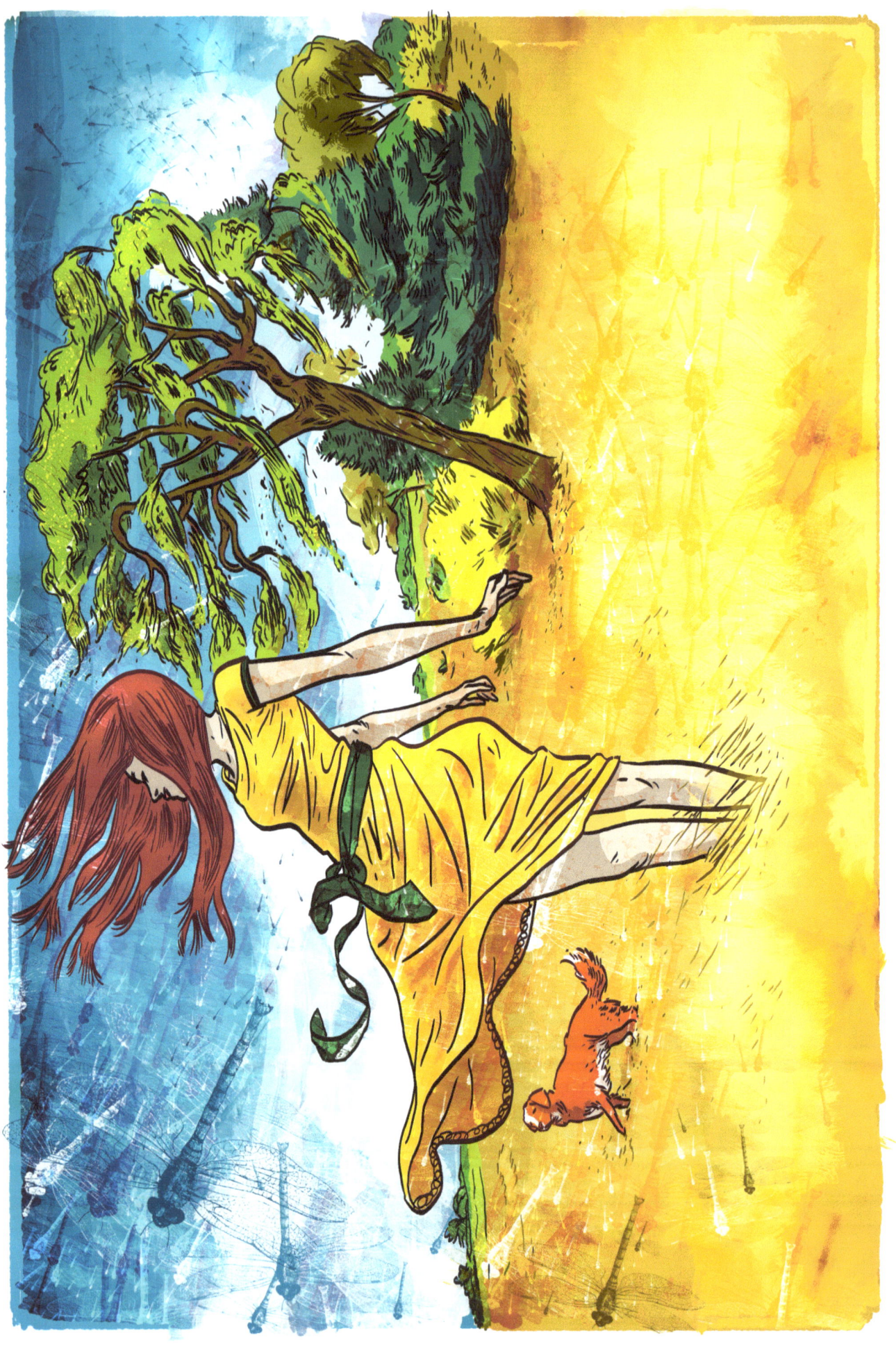

ABOUT THE ARTIST

Kyle T. Webster has illustrated for many national magazines such as *The Progressive*, *PASTE Magazine*, *Utne Reader*, *Venuszine*, and *Governing Magazine*. His work has received recognition from *Communication Arts*, *The Society of Illustrators*, *AIGA*, *Graphis*, and *American Illustration*.

Kyle spent most of his childhood in parts of Asia, where his parents taught at international schools. He went on to study painting and drawing at the University of North Carolina at Greensboro, The prestigious Yale Norfolk art program, the Illustration Academy, and the University of Rennes II in France. He currently resides in North Carolina with his German Princess. This is his first book of editorial work.

www.ingramcontent.com/pod-product-compliance
Lightning Source LLC
Chambersburg PA
CBHW051024180526
45172CB00002B/456